THE NATURE OF GOTHIC A CHAP-
TER OF THE STONES OF VENICE.
BY JOHN RUSKIN.

PREFACE.

HE Chapter which is here put before the reader can be well considered as a separate piece of work, although it contains here & there references to what has gone before in The Stones of Venice. To my mind, and I believe to some others, it is one of the most important things written by the author, & in future days will be considered as one of the very few necessary and inevitable utterances of the century. ❡ To some of us when we first read it, now many years ago, it seemed to point out a new road on which the world should travel. And in spite of all the disappointments of forty years, and although some of us, John Ruskin amongst others, have since learned what the equipment for that journey must be, and how many things must be changed before we are equipped, yet we can still see no other way out of the folly and degradation of Civilization. ❡ For the lesson which Ruskin here teaches us is that art is the expression of man's pleasure in labour; that it is possible for man to rejoice in his work, for, strange as it may seem to us to-day, there have been times when he did rejoice in it; and lastly, that unless man's work once again becomes a pleasure to him, the token of which change will be that beauty is once again a natural and necessary accompaniment of produc-

i

tive labour, all but the worthless must toil in pain, and therefore live in pain. So that the result of the thousands of years of man's effort on the earth must be general unhappiness and universal degradation; unhappiness & degradation, the conscious burden of which will grow in proportion to the growth of man's intelligence, knowledge, and power over material nature.

If this be true, as I for one most firmly believe, it follows that the hallowing of labour by art is the one aim for us at the present day. ❡ If Politics are to be anything else than an empty game, more exciting but less innocent than those which are confessedly games of skill or chance, it is toward this goal of the happiness of labour that they must make. ❡ Science has in these latter days made such stupendous strides, and is attended by such a crowd of votaries, many of whom are doubtless single-hearted, and worship in her not the purse of riches and power, but the casket of knowledge, that she seems to need no more than a little humility to temper the insolence of her triumph, which has taught us everything except how to be happy. Man has gained mechanical victory over nature, which in time to come he may be able to enjoy, instead of starving amidst of it. In those days science also may be happy; yet not before the second birth of art, accompanied by the happiness of labour, has given her rest from the toil of dragging the car of Commerce. ❡ Lastly it may well be that the

human race will never cease striving to solve the problem of the reason for its own existence; yet it seems to me that it may do this in a calmer and more satisfactory mood when it has not to ask the question, Why were we born to be so miserable? but rather, Why were we born to be so happy? ❡ At least it may be said that there is time enough for us to deal with this problem, and that it need not engross the best energies of mankind, when there is so much to do otherwhere.

But for this aim of at last gaining happiness through our daily and necessary labour, the time is short enough, the need so urgent, that we may well wonder that those who groan under the bur-den of unhappiness can think of anything else; and we may well admire and love the man who here called the attention of English-speaking people to this momentous subject, and that with such directness and clearness of insight, that his words could not be disregarded. ❡ I know indeed that Ruskin is not the first man who has put for-ward the possibility and the urgent necessity that men should take pleasure in Labour; for Robert Owen showed how by companionship and good will labour might be made at least endurable; & in France Charles Fourier dealt with the subject at great length; & the whole of his elaborate system for the reconstruction of society is founded on the certain hope of gaining pleasure in labour. But in their times neither Owen nor Fourier could pos-

sibly have found the key to the problem with which Ruskin was provided. Fourier depends, not on art for the motive power of the realization of pleasure in labour, but on incitements, which, though they would not be lacking in any decent state of society, are rather incidental than essential parts of pleasurable work; and on reasonable arrangements, which would certainly lighten the burden of labour, but would not procure for it the element of sensuous pleasure, which is the essence of all true art. Nevertheless, it must be said that Fourier and Ruskin were touched by the same instinct, and it is instructive and hopeful to note how they arrived at the same point by such very different roads.

Some readers will perhaps wonder that in this important Chapter of Ruskin I have found it necessary to consider the ethical & political, rather than what would ordinarily be thought, the artistic side of it. I must answer, that, delightful as is that portion of Ruskin's work which describes, analyses, and criticises art, old and new, yet this is not after all the most characteristic side of his writings. Indeed from the time at which he wrote this chapter here reprinted, those ethical & political considerations have never been absent from his criticism of art; and, in my opinion, it is just this part of his work, fairly begun in the "Nature of Gothic" and brought to its culmination in that great book "Unto this Last," which has had the

most enduring and beneficent effect on his con-
temporaries, and will have through them on suc-
ceeding generations. ❡ John Ruskin the critic of
art has not only given the keenest pleasure to
thousands of readers by his life-like descriptions,
and the ingenuity and delicacy of his analysis of
works of art, but he has let a flood of daylight in-
to the cloud of sham-technical twaddle which was
once the whole substance of "art-criticism," and
is still its staple, and that is much. But it is far
more that John Ruskin the teacher of morals and
politics (I do not use this word in the newspaper
sense), has done serious and solid work towards
that new-birth of Society, without which genuine
art, the expression of man's pleasure in his handi-
work, must inevitably cease altogether, and with
it the hopes of the happiness of mankind.

WILLIAM MORRIS,
Kelmscott House, Hammersmith.
Feb 15th, 1892.

THE NATURE OF GOTHIC.

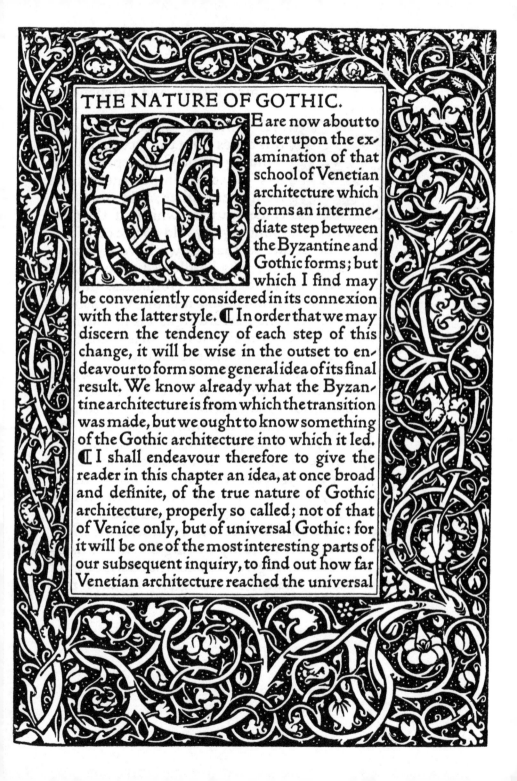

WE are now about to enter upon the examination of that school of Venetian architecture which forms an intermediate step between the Byzantine and Gothic forms; but which I find may be conveniently considered in its connexion with the latter style. ⁜ In order that we may discern the tendency of each step of this change, it will be wise in the outset to endeavour to form some general idea of its final result. We know already what the Byzantine architecture is from which the transition was made, but we ought to know something of the Gothic architecture into which it led. ⁜ I shall endeavour therefore to give the reader in this chapter an idea, at once broad and definite, of the true nature of Gothic architecture, properly so called; not of that of Venice only, but of universal Gothic: for it will be one of the most interesting parts of our subsequent inquiry, to find out how far Venetian architecture reached the universal

or perfect type of Gothic, and how far it either fell short of it, or assumed foreign and independent forms.

HE principal difficulty in doing this arises from the fact that every building of the Gothic period differs in some important respect from every other; and many include features which, if they occurred in other buildings, would not be considered Gothic at all; so that all we have to reason upon is merely, if I may be allowed so to express it, a greater or less degree of Gothicness in each building we examine. And it is this Gothicness, (the character which, according as it is found more or less in a building, makes it more or less Gothic), of which I want to define the nature; and I feel the same kind of difficulty in doing so which would be encountered by any one who undertook to explain, for instance, the Nature of Redness, without any actually red thing to point to, but only orange and purple things. Suppose he had only a piece of heather and a dead oak-leaf to do it with. He might say, the colour which is mixed with the yellow in this oak-leaf, and with the blue in this heather, would be red, if you had it separate; but it would be difficult, nevertheless, to make the abstraction perfectly intelligible: and it is so in a far greater degree to make the abstraction of the Gothic character intelligible, because that

2

character itself is made up of many mingled ideas, and can consist only in their union. ❡ That is to say, pointed arches do not constitute Gothic, nor vaulted roofs, nor flying buttresses, nor grotesque sculptures; but all or some of these things, and many other things with them, when they come together so as to have life.

OBSERVE also, that, in the definition proposed, I shall only endeavour to analyze the idea which I suppose already to exist in the reader's mind. We all have some notion, most of us a very determined one, of the meaning of the term Gothic; but I know that many persons have this idea in their minds without being able to define it: that is to say, understanding generally that Westminster Abbey is Gothic, and St. Paul's is not, that Strasburg Cathedral is Gothic, and St. Peter's is not, they have, nevertheless, no clear notion of what it is that they recognize in the one or miss in the other, such as would enable them to say how far the work at Westminster or Strasburg is good and pure of its kind; still less to say of any nondescript building, like St. James's Palace or Windsor Castle, how much right Gothic element there is in it, and how much wanting. And I believe this inquiry to be a pleasant and profitable one; and that there will be found something more than usually interesting in tracing out this grey,

shadowy, many-pinnacled image of the Gothic
spirit within us; and discerning what fellowship
there is between it and our Northern hearts.
℃ And if, at any point of the inquiry, I should in-
terfere with any of the reader's previously formed
conceptions, and use the term Gothic in any sense
which he would not willingly attach to it, I do not
ask him to accept, but only to examine and under-
stand, my interpretation, as necessary to the in-
telligibility of what follows in the rest of the work.

E have, then, the Gothic character
submitted to our analysis, just as
the rough mineral is submitted to
that of the chemist, entangled with
many other foreign substances,
itself perhaps in no place pure, or
ever to be obtained or seen in purity for more than
an instant; but nevertheless a thing of definite
and separate nature; however inextricable or con-
fused in appearance. Now observe: the chemist
defines his mineral by two separate kinds of char-
acter; one external, its crystalline form, hardness,
lustre, etc.; the other internal, the proportions and
nature of its constituent atoms. Exactly in the
same manner, we shall find that Gothic architec-
ture has external forms and internal elements.
Its elements are certain mental tendencies of the
builders, legibly expressed in it; as fancifulness,
love of variety, love of richness, & such others. Its
external forms are pointed arches, vaulted roofs,
etc. And unless both the elements & the forms are

4

there, we have no right to call the style Gothic. It is not enough that it has the Form, if it have The Nature
not also the power and life. It is not enough that it of Gothic
has the Power, if it have not the form. We must
therefore inquire into each of these characters suc-
cessively; and determine first, what is the Mental
Expression, & secondly, what the Material Form
of Gothic architecture, properly so called. ❡ First,
Mental Power or Expression. What characters,
we have to discover, did the Gothic builders love,
or instinctively express in their work, as distin-
guished from all other builders?

ET us go back for a moment to our
chemistry, & note that, in defining
a mineral by its constituent parts,
it is not one nor another of them,
that can make up the mineral, but
the union of all: for instance, it is
neither in charcoal, nor in oxygen, nor in lime,
that there is the making of chalk, but in the com-
bination of all three in certain measures; they are
all found in very different things from chalk, and
there is nothing like chalk either in charcoal or in
oxygen, but they are nevertheless necessary to its
existence. ❡ So in the various mental characters
which make up the soul of Gothic. It is not
one nor another that produces it; but their union
in certain measures. Each one of them is found
in many other architectures beside Gothic; but
Gothic cannot exist where they are not found, or,

5 b 3

at least, where their place is not in some way sup-
plied. Only there is this great difference between
the composition of the mineral and of the architec-
tural style, that if we withdraw one of its elements
from the stone, its form is utterly changed, and its
existence as such and such a mineral is destroyed;
but if we withdraw one of its mental elements
from the Gothic style, it is only a little less Gothic
than it was before, and the union of two or three
of its elements is enough already to bestow a
certain Gothicness of character, which gains in
intensity as we add the others, and loses as we
again withdraw them.

BELIEVE, then, that the charac-
teristic or moral elements of Gothic
are the following, placed in the order
of their importance:
1. Savageness.
2. Changefulness.
3. Naturalism.
4. Grotesqueness.
5. Rigidity.
6. Redundance.
❡ These characters are here expressed as belong-
ing to the building; as belonging to the builder,
they would be expressed thus: 1. Savageness or
Rudeness. 2. Love of Change. 3. Love of Nature.
4. Disturbed Imagination. 5. Obstinacy. 6. Gen-
erosity. And I repeat, that the withdrawal of any
one, or any two, will not at once destroy the Gothic

character of a building, but the removal of a ma
jority of them will. I shall proceed to examine them in their order.

AVAGENESS. I am not sure when the word "Gothic" was first gene
rically applied to the ar
chitecture of the North; but I presume that, what
ever the date of its origi
nal usage, it was intend
ed to imply reproach, and express the barbaric char
acter of the nations among whom that architect
ure arose. It never implied that they were liter
ally of Gothic lineage, far less that their architect
ure had been originally invented by the Goths themselves; but it did imply that they and their buildings together exhibited a degree of sternness and rudeness, which, in contradistinction to the character of Southern and Eastern nations, ap
peared like a perpetual reflection of the contrast between the Goth and the Roman in their first encounter. And when that fallen Roman, in the utmost impotence of his luxury, and insolence of his guilt, became the model for the imitation of civilized Europe, at the close of the so-called Dark ages, the word Gothic became a term of un
mitigated contempt, not unmixed with aversion. From that contempt, by the exertion of the an

Savageness tiquaries and architects of this century, Gothic architecture has been sufficiently vindicated; and perhaps some among us, in our admiration of the magnificent science of its structure, & sacredness of its expression, might desire that the term of ancient reproach should be withdrawn, and some other of more apparent honourableness, adopted in its place. There is no chance, as there is no need, of such a substitution. As far as the epithet was used scornfully, it was used falsely; but there is no reproach in the word, rightly understood; on the contrary, there is a profound truth, which the instinct of mankind almost unconsciously recognizes. It is true, greatly and deeply true, that the architecture of the North is rude and wild; but it is not true, that, for this reason, we are to condemn it, or despise. Far otherwise: I believe it is in this very character that it deserves our profoundest reverence.

THE charts of the world which have been drawn up by modern science have thrown into a narrow space the expression of a vast amount of knowledge, but I have never yet seen any one pictorial enough to enable the spectator to imagine the kind of contrast in physical character which exists between Northern and Southern countries. We know the differences in detail, but we have not that broad glance and grasp which would enable us to feel

8

them in their fulness. We know that gentians grow on the Alps, and olives on the Apennines; but we do not enough conceive for ourselves that varie/ gated mosaic of the world's surface which a bird sees in its migration, that difference between the district of the gentian and of the olive which the stork and the swallow see far off, as they lean upon the sirocco wind. ⁅ Let us, for a moment, try to raise ourselves even above the level of their flight, and imagine the Mediterranean lying beneath us like an irregular lake, and all its ancient promon/ tories sleeping in the sun: here and there an angry spot of thunder, a grey stain of storm, moving upon the burning field; and here and there a fixed wreath of white volcano smoke, surrounded by its circle of ashes; but for the most part a great peace/ fulness of light, Syria and Greece, Italy & Spain, laid like pieces of a golden pavement into the sea/ blue, chased, as we stoop nearer to them, with bossy beaten work of mountain chains, & glowing softly with terraced gardens, & flowers heavy with frankincense, mixed among masses of laurel, and orange, and plumy palm, that abate with their grey/green shadows the burning of the marble rocks, & of the ledges of porphyry sloping under lucent sand. Then let us pass farther towards the north, until we see the orient colours change gradu/ ally into a vast belt of rainy green, where the pas/ tures of Switzerland, & poplar valleys of France, and dark forests of the Danube and Carpathians

9

Savageness stretch from the mouths of the Loire to those of the Volga, seen through clefts in grey swirls of rain-cloud & flaky veils of the mist of the brooks, spreading low along the pasture lands: and then, farther north still, to see the earth heave into mighty masses of leaden rock and heathy moor, bordering with a broad waste of gloomy purple that belt of field and wood, & splintering into ir-regular & grisly islands amidst the northern seas, beaten by storm, and chilled by ice-drift, and tor-mented by furious pulses of contending tide, until the roots of the last forests fail from among the hill ravines, & the hunger of the north wind bites their peaks into barrenness; and, at last, the wall of ice, durable like iron, sets, deathlike, its white teeth against us out of the polar twilight. And, having once traversed in thought this gradation of the zoned iris of the earth in all its material vast-ness, let us go down nearer to it, and watch the parallel change in the belt of animal life; the mul-titudes of swift and brilliant creatures that glance in the air & sea, or tread the sands of the southern zone; striped zebras and spotted leopards, glis-tening serpents, and birds arrayed in purple and scarlet. ⁋ Let us contrast their delicacy and bril-liancy of colour, and swiftness of motion, with the frost-cramped strength, and shaggy covering, and dusky plumage of the northern tribes; contrast the Arabian horse with the Shetland, the tiger and leopard with the wolf and bear, the antelope with

the elk, the bird of paradise with the osprey: and
then, submissively acknowledging the great laws
by which the earth and all that it bears are ruled
throughout their being, let us not condemn, but
rejoice in the expression by man of his own rest
in the statutes of the lands that gave him birth.
Let us watch him with reverence as he sets side
by side the burning gems, and smooths with soft
sculpture the jasper pillars, that are to reflect a
ceaseless sunshine, and rise into a cloudless sky:
but not with less reverence let us stand by him,
when, with rough strength and hurried stroke, he
smites an uncouth animation out of the rocks
which he has torn from among the moss of the
moorland, and heaves into the darkened air the
pile of iron buttress and rugged wall, instinct with
a work of an imagination as wild and wayward as
the northern sea; creations of ungainly shape and
rigid limb, but full of wolfish life; fierce as the
winds that beat, and changeful as the clouds that
shade them. ❡ There is, I repeat, no degradation,
no reproach in this, but all dignity and honour-
ableness: and we should err grievously in refusing
either to recognize as an essential character of the
existing architecture of the North, or to admit as a
desirable character in that which it yet may be, this
wildness of thought, and roughness of work; this
look of mountain brotherhood between the cathe-
dral and the Alp; this magnificence of sturdy
power, put forth only the more energetically be-

11

cause the fine finger-touch was chilled away by the frosty wind, & the eye dimmed by the moor-mist, or blinded by the hail; this outspeaking of the strong spirit of men who may not gather redund-ant fruitage from the earth, not bask in dreamy be-nignity of sunshine, but must break the rock for bread, and cleave the forest for fire, & show, even in what they did for their delight, some of the hard habits of the arm and heart that grew on them as they swung the axe or pressed the plough.

IF, however, the savageness of Goth-ic architecture, merely as an expres-sion of its origin among Northern nations, may be considered, in some sort, a noble character, it possesses a higher nobility still, when consi-dered as an index, not of climate, but of religious principle. ❡ In the 13th and 14th paragraphs of Chapter XXI. of the first volume of The Stones of Venice, it was noticed that the systems of ar-chitectural ornament, properly so called, might be divided into three: 1. Servile ornament, in which the execution or power of the inferior work-man is entirely subjected to the intellect of the higher; 2. Constitutional ornament, in which the executive inferior power is, to a certain point, emancipated and independent, having a will of its own, yet confessing its inferiority and rendering obedience to higher powers; and 3. Revolution-ary ornament, in which no executive inferiority

is admitted at all. I must here explain the nature
of these divisions at somewhat greater length.
⦅ Of Servile ornament, the principal schools are
the Greek, Ninevite and Egyptian; but their ser-
vility is of different kinds. The Greek master-
workman was far advanced in knowledge and
power above the Assyrian or Egyptian. Neither
he nor those for whom he worked could endure
the appearance of imperfection in anything; and,
therefore,what ornament he appointed to be done
by those beneath him was composed of mere geo-
metrical forms, balls, ridges, and perfectly sym-
metrical foliage, which could be executed with
absolute precision by line and rule, and were as
perfect in their way, when completed, as his own
figure sculpture. The Assyrian and Egyptian, on
the contrary, less cognisant of accurate form in
anything, were content to allow their figure sculp-
ture to be executed by inferior workmen, but low-
ered the method of its treatment to a standard
which every workman could reach, and then
trained him by discipline so rigid, that there was
no chance of his falling beneath the standard ap-
pointed. The Greek gave to the lower workman
no subject which he could not perfectly execute.
The Assyrian gave him subjects which he could
only execute imperfectly, but fixed a legal stand-
ard for his imperfection. The workman was, in
both systems, a slave. ⦅ The third kind of orna-
ment, the Renaissance, is that in which the in-

13

ferior detail becomes principal, the executor of every minor portion being required to exhibit skill and possess knowledge as great as that which is possessed by the master of the design; and in the endeavour to endow him with this skill and knowledge, his own original power is overwhelm-ed, and the whole building becomes a wearisome exhibition of well-educated imbecility. We must fully inquire into the nature of this form of error, when we arrive at the examination of the Renais-sance schools.

BUT in the mediæval, or especially Christian, system of ornament, this slavery is done away with al-together; Christianity having re-cognized, in small things as well as great, the individual value of every soul. But it not only recognizes its value; it con-fesses its imperfection, in only bestowing dignity upon the acknowledgment of unworthiness. That admission of lost power and fallen nature, which the Greek or Ninevite felt to be intensely painful, and, as far as might be, altogether refused, the Christian makes daily and hourly, contemplating the fact of it without fear, as tending, in the end, to God's greater glory. Therefore, to every spirit which Christianity summons to her service, her exhortation is: Do what you can, & confess frankly what you are unable to do; neither let your effort be shortened for fear of failure, nor your confession

14

silenced for fear of shame. ⁅And it is, perhaps,
the principal admirableness of the Gothic schools
of architecture, that they thus receive the results
of the labour of inferior minds; and out of frag-
ments full of imperfection, and betraying that im-
perfection in every touch, indulgently raise up a
stately and unaccusable whole.

UT the modern English mind has
this much in common with that of
the Greek, that it intensely desires,
in all things, the utmost comple-
tion or perfection compatible with
their nature. This is a noble char-
acter in the abstract, but becomes ignoble when it
causes us to forget the relative dignities of that na-
ture itself, and to prefer the perfectness of the
lower nature to the imperfection of the higher; not
considering that as, judged by such a rule, all the
brute animals would be preferable to man, because
more perfect in their functions and kind, and yet
are always held inferior to him, so also in the
works of man, those which are more perfect in
their kind are always inferior to those which are,
in their nature, liable to more faults and short-
comings. For the finer the nature, the more flaws
it will show through the clearness of it; and it is a
law of this universe, that the best things shall be
seldomest seen in their best form. The wild grass
grows well and strongly, one year with another;
but the wheat is, according to the greater nobleness

15

Savageness of its nature, liable to the bitterer blight. And therefore, while in all things that we see or do, we are to desire perfection, and strive for it, we are nevertheless not to set the meaner thing, in its narrow accomplishment, above the nobler thing, in its mighty progress; not to esteem smooth minuteness above shattered majesty; not to prefer mean victory to honourable defeat; not to lower the level of our aim, that we may the more surely enjoy the complacency of success. But, above all, in our dealings with the souls of other men, we are to take care how we check, by severe requirement or narrow caution, efforts which might otherwise lead to a noble issue; and, still more, how we withhold our admiration from great excellences, because they are mingled with rough faults. ❡ Now, in the make and nature of every man, however rude or simple, whom we employ in manual labour, there are some powers for better things: some tardy imagination, torpid capacity of emotion, tottering steps of thought, there are, even at the worst; & in most cases it is all our own fault that they are tardy or torpid. But they cannot be strengthened, unless we are content to take them in their feebleness, and unless we prize & honour them in their imperfection above the best and most perfect manual skill. And this is what we have to do with all our labourers; to look for the thoughtful part of them, and get that out of them, whatever we lose for it, whatever faults & errors we are obliged

to take with it. For the best that is in them cannot
Savageness
manifest itself, but in company with much error.
℣ Understand this clearly: You can teach a man
to draw a straight line, and to cut one; to strike a
curved line, and to carve it; and to copy and carve
any number of given lines or forms, with admir‐
able speed and perfect precision; and you find his
work perfect of its kind: but if you ask him to
think about any of those forms, to consider if he
cannot find any better in his own head, he stops;
his execution becomes hesitating; he thinks, and
ten to one he thinks wrong; ten to one he makes
a mistake in the first touch he gives to his work as
a thinking being. But you have made a man of
him for all that. He was only a machine before,
an animated tool.

AND observe, you are put to stern
choice in this matter. You must
either make a tool of the creature,
or a man of him. You cannot make
both. Men were not intended to
work with the accuracy of tools, to
be precise and perfect in all their actions. If you
will have that precision out of them, & make their
fingers measure degrees like cog‐wheels, and their
arms strike curves like compasses, you must unhu‐
manize them. All the energy of their spirits must
be given to make cogs & compasses of themselves.
All their attention and strength must go to the ac‐
complishment of the mean act. The eye of the soul

17 C 1

Savageness must be bent upon the finger-point, and the soul's force must fill all the invisible nerves that guide it, ten hours a day, that it may not err from its steely precision, and so soul and sight be worn away, and the whole human being be lost at last; a heap of sawdust, so far as its intellectual work in this world is concerned; saved only by its Heart, which cannot go into the form of cogs & compasses, but expands, after the ten hours are over, into fireside humanity. On the other hand, if you will make a man of the working creature, you cannot make a tool. Let him but begin to imagine, to think, to try to do anything worth doing; and the engine-turned precision is lost at once. Out come all his roughness, all his dulness, all his incapability; shame upon shame, failure upon failure, pause after pause; but out comes the whole majesty of him also; and we know the height of it only when we see the clouds settling upon him. And, whether the clouds be bright or dark, there will be transfiguration behind and within them.

AND now, reader, look round this English room of yours, about which you have been proud so often, because the work of it was so good and strong, and the ornaments of it so finished. Examine again all those accurate mouldings and perfect polishings, and unerring adjustments of the seasoned wood and tempered steel. Many a time

you have exulted over them, & thought how great
England was, because her slightest work was done
so thoroughly. Alas! if read rightly, these perfect-
nesses are signs of a slavery in our England a
thousand times more bitter and more degrading
than that of the scourged African, or helot Greek.
Men may be beaten, chained, tormented, yoked
like cattle, slaughtered like summer flies, and yet
remain in one sense, and the best sense, free. But
to smother their souls within them, to blight and
hew into rotting pollards the suckling branches
of their human intelligence, to make the flesh
and skin which, after the worm's work on it, is to
see God, into leathern thongs to yoke machinery
with, this it is to be slave-masters indeed; & there
might be more freedom in England, though her
feudal lords' lightest words were worth men's
lives, and though the blood of the vexed husband-
man dropped in the furrows of her fields, than
there is while the animation of her multitudes is
sent like fuel to feed the factory smoke, and the
strength of them is given daily to be wasted into
the fineness of a web, or racked into the exactness
of a line.

AND, on the other hand, go forth
again to gaze upon the old cathe-
dral front, where you have smiled
so often at the fantastic ignorance
of the old sculptors: examine once
more those ugly goblins, and form-

less monsters, and stern statues, anatomiless and rigid; but do not mock at them, for they are signs of the life and liberty of every workman who struck the stone; a freedom of thought, and rank in scale of being, such as no laws, no charters, no charities can secure; but which it must be the first aim of all Europe at this day to regain for her children.

ET me not be thought to speak wildly or extravagantly. It is verily this degradation of the operative into a machine, which, more than any other evil of the times, is leading the mass of the nations everywhere into vain, incoherent, destructive struggling for a freedom of which they cannot explain the nature to themselves. Their universal outcry against wealth, and against nobility, is not forced from them either by the pressure of famine, or the sting of mortified pride. These do much, and have done much in all ages; but the foundations of society were never yet shaken as they are at this day. It is not that men are ill fed, but that they have no pleasure in the work by which they make their bread, & therefore look to wealth as the only means of pleasure. It is not that men are pained by the scorn of the upper classes, but they cannot endure their own; for they feel that the kind of labour to which they are condemned is verily a degrading one, and makes them less than men. Never had the upper classes so much sympathy

20

with the lower, or charity for them, as they have at Savageness
this day, and yet never were they so much hated
by them; for, of old, the separation between the
noble and the poor was merely a wall built by law;
now it is a veritable difference in level of standing,
a precipice between upper and lower grounds in
the field of humanity, and there is pestilential air
at the bottom of it. I know not if a day is ever to
come when the nature of right freedom will be
understood, and when men will see that to obey
another man, to labour for him, yield reverence to
him or to his place, is not slavery. It is often the
best kind of liberty, liberty from care. The man
who says to one, Go, and he goeth, and to an-
other, Come, and he cometh, has, in most cases,
more sense of restraint and difficulty than the man
who obeys him. The movements of the one are
hindered by the burden on his shoulder; of the
other by the bridle on his lips: there is no way by
which the burden may be lightened; but we need
not suffer from the bridle if we do not champ at it.
To yield reverence to another, to hold ourselves
and our lives at his disposal, is not slavery; often
it is the noblest state in which a man can live in
this world. There is, indeed, a reverence which is
servile, that is to say, irrational or selfish: but there
is also noble reverence, that is to say, reasonable
and loving; and a man is never so noble as when
he is reverent in this kind; nay, even if the feeling
pass the bounds of mere reason, so that it be loving,

a man is raised by it. Which had, in reality, most of the serf nature in him, the Irish peasant who was lying in wait yesterday for his landlord, with his musket muzzle thrust through the ragged hedge; or that old mountain servant, who 200 years ago, at Inverkeithing, gave up his own life and the lives of his seven sons for his chief? as each fell, calling forth his brother to the death, "Another for Hector!" And therefore, in all ages and all countries, reverence has been paid & sacri-fice made by men to each other, not only without complaint, but rejoicingly; and famine, and peril, and sword, and all evil, and all shame, have been borne willingly in the causes of masters and kings; for all these gifts of the heart ennobled the men who gave, not less than the men who received them, and nature prompted, and God rewarded the sacrifice. But to feel their souls withering within them, unthanked, to find their whole being sunk into an unrecognized abyss, to be counted off into a heap of mechanism numbered with its wheels, and weighed with its hammer strokes, this nature bade not; this God blesses not; this humanity for no long time is able to endure.

E have much studied and much perfected, of late, the great civilized invention of the division of labour; only we give it a false name. It is not, truly speaking, the labour that is divided; but the men: Divided

22

into mere segments of men, broken into small
fragments and crumbs of life; so that all the little
piece of intelligence that is left in a man is not
enough to make a pin, or a nail, but exhausts itself
in making the point of a pin or the head of a nail.
Now it is a good & desirable thing, truly, to make
many pins in a day; but if we could only see with
what crystal sand their points were polished, sand
of human soul, much to be magnified before it
can be discerned for what it is, we should think
there might be some loss in it also. And the great
cry that rises from all our manufacturing cities,
louder than their furnace blast, is all in very deed
for this, that we manufacture everything there ex-
cept men; we blanch cotton, and strengthen steel,
and refine sugar, & shape pottery; but to brighten,
to strengthen, to refine, or to form a single living
spirit, never enters into our estimate of advan-
tages. And all the evil to which that cry is urging
our myriads can be met only in one way: not by
teaching nor preaching, for to teach them is but to
show them their misery, and to preach to them, if
we do nothing more than preach, is to mock at it.
It can be met only by a right understanding, on the
part of all classes, of what kinds of labour are good
for men, raising them, and making them happy;
by a determined sacrifice of such convenience, or
beauty, or cheapness as is to be got only by the
degradation of the workman; and by equally de-
termined demand for the products and results of
healthy and ennobling labour.

ND how, it will be asked, are these products to be recognized, and this demand to be regulated? Easily: by the observance of three broad and simple rules:

1. NEVER encourage the manufacture of any article not absolutely necessary, in the production of which Invention has no share.

2. NEVER demand an exact finish for its own sake, but only for some practical or noble end.

3. NEVER encourage imitation or copying of any kind, except for the sake of preserving records of great works.

The second of these principles is the only one which directly rises out of the consideration of our immediate subject; but I shall briefly explain the meaning and extent of the first also, reserving the enforcement of the third for another place.

1. NEVER encourage the manufacture of any-thing not necessary, in the production of which invention has no share. ⁊ For instance. Glass beads are utterly unnecessary, & there is no design or thought employed in their manufacture. They are formed by first drawing out the glass into rods; these rods are chopped up into fragments of the size of beads by the human hand, & the fragments are then rounded in the furnace. The men who chop up the rods sit at their work all day, their hands vibrating with a perpetual and exquisitely

24

timed palsy, & the beads dropping beneath their
vibration like hail. Neither they, nor the men who
draw out the rods or fuse the fragments, have the
smallest occasion for the use of any single human
faculty; & every young lady, therefore, who buys
glass beads is engaged in the slave-trade, and in a
much more cruel one than that which we have so
long been endeavouring to put down. But glass
cups and vessels may become the subjects of ex-
quisite invention; and if in buying these we pay
for the invention, that is to say, for the beautiful
form, or colour, or engraving, & not for mere finish
of execution, we are doing good to humanity.

O, again, the cutting of precious
stones, in all ordinary cases, re-
quires little exertion of any mental
faculty; some tact and judgment in
avoiding flaws, & so on, but noth-
ing to bring out the whole mind.
Every person who wears cut jewels merely for
the sake of their value is, therefore, a slave-driver.
But the working of the goldsmith, and the various
designing of grouped jewellery and enamel-work,
may become the subject of the most noble human
intelligence. Therefore, money spent in the pur-
chase of well-designed plate, of precious engraved
vases, cameos, or enamels, does good to humanity;
and, in work of this kind, jewels may be employed
to heighten its splendour; and their cutting is then
a price paid for the attainment of a noble end, and
thus perfectly allowable.

I SHALL perhaps press this law farther elsewhere, but our im, mediate concern is chiefly with the second, namely, never to demand an exact finish, when it does not lead to a noble end. For observe, I have only dwelt upon the rudeness of Gothic, or any other kind of imperfectness, as admirable, where it was impossible to get design or thought without it. If you are to have the thought of a rough and untaught man, you must have it in a rough and untaught way; but from an educate d man, who can without effort express his thoughts in an educated way, take the graceful expression, and be thankful. Only get the thought, and do not silence the peasant because he cannot speak good grammar, or until you have taught him his gram, mar. Grammar and refinement are good things, both, only be sure of the better thing first. And thus in art, delicate finish is desirable from the greatest masters, and is always given by them. In some places Michael Angelo, Leonardo, Phidias, Perugino, Turner, all finished with the most ex, quisite care; and the finish they give always leads to the fuller accomplishment of their noble pur, poses. But lower men than these cannot finish, for it requires consummate knowledge to finish consummately, and then we must take their thoughts as they are able to give them. So the rule is simple: always look for invention first, & after

that, for such execution as will help the invention,
and as the inventor is capable of without painful
effort, and no more. Above all, demand no refine-
ment of execution where there is no thought, for
that is slaves' work, unredeemed. Rather choose
rough work than smooth work, so only that the
practical purpose be answered, and never imagine
there is reason to be proud of anything that may
be accomplished by patience and sand-paper.

 SHALL only give one example,
which however will show the reader
what I mean, from the manufacture
already alluded to, that of glass. Our
modern glass is exquisitely clear in
its substance, true in its form, ac-
curate in its cutting. We are proud of this. We
ought to be ashamed of it. The old Venice glass
was muddy, inaccurate in all its forms, & clumsily
cut, if at all. And the old Venetian was justly proud
of it. For there is this difference between the Eng-
lish & Venetian workman, that the former thinks
only of accurately matching his patterns, and get-
ting his curves perfectly true & his edges perfectly
sharp, and becomes a mere machine for rounding
curves and sharpening edges; while the old Vene-
tian cared not a whit whether his edges were sharp
or not, but he invented a new design for every
glass that he made, and never moulded a handle
or a lip without a new fancy in it. And therefore,
though some Venetian glass is ugly and clumsy

27

Savageness enough when made by clumsy and uninventive workmen, other Venetian glass is so lovely in its forms that no price is too great for it; and we never see the same form in it twice. Now you cannot have the finish and the varied form too. If the workman is thinking about his edges, he cannot be thinking of his design; if of his design, he cannot think of his edges. Choose whether you will pay for the lovely form or the perfect finish, and choose at the same moment whether you will make the worker a man or a grindstone.

NAY, but the reader interrupts me: "If the workman can design beautifully, I would not have him kept at the furnace. Let him be taken away and made a gentleman, and have a studio, and design his glass there, and I will have it blown and cut for him by common workmen, and so I will have my design and my finish too." ❡ All ideas of this kind are founded upon two mistaken suppositions: the first, that one man's thought can be, or ought to be, executed by another man's hands; the second, that manual labour is a degradation, when it is governed by intellect. ❡ On a large scale, and in work determinable by line and rule, it is indeed both possible and necessary that the thoughts of one man should be carried out by the labour of others; in this sense I have already defined the best architecture to be the expression of

the mind of manhood by the hands of childhood. Savageness
But on a smaller scale, and in a design which
cannot be mathematically defined, one man's
thoughts can never be expressed by another: and
the difference between the spirit of touch of the
man who is inventing, and of the man who is
obeying directions, is often all the difference be-
tween a great and a common work of art. How
wide the separation is between original & second-
hand execution, I shall endeavour to show else-
where; it is not so much to our purpose here as to
mark the other and more fatal error of despising
manual labour when governed by intellect: for it
is no less fatal an error to despise it when thus re-
gulated by intellect, than to value it for its own
sake. We are always in these days endeavouring
to separate the two; we want one man to be al-
ways thinking, and another to be always working,
and we call one a gentleman, and the other an
operative; whereas the workman ought often
to be thinking, and the thinker often to be work-
ing, and both should be gentlemen, in the best
sense. As it is, we make both ungentle, the one
envying, the other despising, his brother; and the
mass of society is made up of morbid thinkers, and
miserable workers. Now it is only by labour that
thought can be made healthy, and only by thought
that labour can be made happy, and the two cannot
be separated with impunity. It would be well if all
of us were good handicraftsmen in some kind, and

the dishonour of manual labour done away with altogether; so that though there should still be a trenchant distinction of race between nobles and commoners, there should not, among the latter, be a trenchant distinction of employment, as between idle and working men, or between men of liberal and illiberal professions. All professions should be liberal, and there should be less pride felt in peculiarity of employment, and more in excellence of achievement. And yet more, in each several profession, no master should be too proud to do its hardest work. The painter should grind his own colours; the architect work in the mason's yard with his men; the master manufacturer be himself a more skilful operative than any man in his mills; and the distinction between one man and another be only in experience and skill, and the authority and wealth which these must naturally and justly obtain.

I SHOULD be led far from the matter in hand, if I were to pursue this interesting subject. Enough, I trust, has been said to show the reader that the rudeness or imperfection which at first rendered the term "Gothic" one of reproach is indeed, when rightly understood, one of the most noble characters of Christian architecture, & not only a noble but an essential one. It seems a fantastic paradox, but it is nevertheless a most important truth, that

no architecture can be truly noble which is not imperfect. And this is easily demonstrable. For since the architect, whom we will suppose capable of doing all in perfection, cannot execute the whole with his own hands, he must either make slaves of his workmen in the old Greek, and present English fashion, and level his work to a slave's capacities, which is to degrade it; or else he must take his workmen as he finds them, and let them show their weaknesses together with their strength, which will involve the Gothic imperfection, but render the whole work as noble as the intellect of the age can make it.

BUT the principle may be stated more broadly still. I have confined the illustration of it to architecture, but I must not leave it as if true of architecture only. Hitherto I have used the words imperfect and perfect merely to distinguish between work grossly unskilful, and work executed with average precision and science; and I have been pleading that any degree of unskilfulness should be admitted, so only that the labourer's mind had room for expression. But, accurately speaking, no good work whatever can be perfect, and THE DEMAND FOR PERFECTION IS ALWAYS A SIGN OF A MISUNDERSTANDING OF THE ENDS OF ART.

HIS for two reasons, both based on everlasting laws. The first, that no great man ever stops working till he has reached his point of failure: that is to say, his mind is always far in advance of his powers of execution, and the latter will now and then give way in trying to follow it; besides that he will always give to the inferior portions of his work only such inferior attention as they require; and according to his greatness he becomes so ac⁄customed to the feeling of dissatisfaction with the best he can do, that in moments of lassitude or anger with himself he will not care though the beholder be dissatisfied also. I believe there has only been one man who would not acknowledge this necessity, and strove always to reach perfec⁄tion, Leonardo; the end of his vain effort being merely that he would take ten years to a picture and leave it unfinished. And therefore, if we are to have great men working at all, or less men doing their best, the work will be imperfect, however

See Appendix Note A. beautiful. Of human work none but what is bad can be perfect, in its own bad way.

HE second reason is, that imper⁄fection is in some sort essential to all that we know of life. It is the sign of life in a mortal body, that is to say, of a state of progress & change. Nothing that lives is, or can be,

32

rigidly perfect; part of it is decaying, part nascent.
The foxglove blossom, a third part bud, a third
part past, a third part in full bloom, is a type of the
life of this world. And in all things that live there
are certain irregularities and deficiencies which
are not only signs of life, but sources of beauty.
No human face is exactly the same in its lines on
each side, no leaf perfect in its lobes, no branch in
its symmetry. All admit irregularity as they imply
change; and to banish imperfection is to destroy
expression, to check exertion, to paralyze vitality.
All things are literally better, lovelier, and more
beloved for the imperfections which have been
divinely appointed, that the law of human life
may be Effort, and the law of human judgment,
Mercy. ❡ Accept this then for a universal law,
that neither architecture nor any other noble work
of man can be good unless it be imperfect; & let us
be prepared for the otherwise strange fact, which
we shall discern clearly as we approach the period
of the Renaissance, that the first cause of the fall of
the arts of Europe was a relentless requirement of
perfection, incapable alike either of being silenced
by veneration for greatness, or softened into for-
giveness of simplicity. ❡ Thus far then of the
Rudeness or Savageness, which is the first mental
element of Gothic architecture. It is an element
in many other healthy architectures, also, as the
Byzantine and Romanesque; but true Gothic
cannot exist without it.

d 1

HE second mental ele-
ment above named was
CHANGEFUL-
NESS, or Variety. I
have already enforced
the allowing independ-
ent operation to the in-
ferior workman, simply
as a duty to him, and as
ennobling the architect-
ure by rendering it more Christian. We have now
to consider what reward we obtain for the per-
formance of this duty, namely, the perpetual
variety of every feature of the building. ❡ Wher-
ever the workman is utterly enslaved, the parts
of the building must of course be absolutely like
each other; for the perfection of his execution can
only be reached by exercising him in doing one
thing, and giving him nothing else to do. The
degree in which the workman is degraded may
be thus known at a glance, by observing whether
the several parts of the building are similar or
not; and if, as in Greek work, all the capitals are
alike, and all the mouldings unvaried, then the
degradation is complete; if, as in Egyptian or
Ninevite work, though the manner of executing
certain figures is always the same, the order of de-
sign is perpetually varied, the degradation is less
total; if, as in Gothic work, there is perpetual
change both in design & execution, the workman
must have been altogether set free.

34

OW much the beholder gains from the liberty of the labourer may perhaps be questioned in England, where one of the strongest instincts in nearly every mind is that Love of Order which makes us desire that our house windows should pair like our carriage horses, and allows us to yield our faith unhesitatingly to architectural theories which fix a form for everything, and forbid variation from it. I would not impeach love of order: it is one of the most useful elements of the English mind; it helps us in our commerce & in all purely practical matters; and it is in many cases one of the foundation stones of morality. Only do not let us suppose that love of order is love of art. It is true that order, in its highest sense, is one of the necessities of art, just as time is a necessity of music; but love of order has no more to do with our right enjoyment of architecture or painting, than love of punctuality with the appreciation of an opera. Experience, I fear, teaches us that accurate and methodical habits in daily life are seldom characteristic of those who either quickly perceive, or richly possess, the creative powers of art; there is, however, nothing inconsistent between the two instincts, and nothing to hinder us from retaining our business habits, and yet fully allowing and enjoying the noblest gifts of Invention. We already do so, in every other branch of art except architecture,

d 2

and we only do not so there because we have been
taught that it would be wrong. Our architects
gravely inform us that, as there are four rules of
arithmetic, there are five orders of architecture;
we, in our simplicity, think that this sounds con-
sistent, & believe them. They inform us also that
there is one proper form for Corinthian capitals,
another for Doric, & another for Ionic. We, con-
sidering that there is also a proper form for the
letters A, B, and C, think that this also sounds con-
sistent, & accept the proposition. Understanding,
therefore, that one form of the said capitals is pro-
per, and no other, & having a conscientious horror
of all impropriety, we allow the architect to pro-
vide us with the said capitals, of the proper form,
in such and such a quantity, & in all other points to
take care that the legal forms are observed; which
having done, we rest in forced confidence that we
are well housed.

BUT our higher instincts are not de-
ceived. We take no pleasure in the
building provided for us, resem-
bling that which we take in a new
book or a new picture. We may be
proud of its size, complacent in its
correctness, & happy in its convenience. We may
take the same pleasure in its symmetry and work-
manship as in a well-ordered room, or a skilful
piece of manufacture. And this we suppose to be
all the pleasure that architecture was ever intended

to give us. The idea of reading a building as we would read Milton or Dante, and getting the same kind of delight out of the stones as out of the stanzas, never enters our mind for a moment. And for good reason: There is indeed rhythm in the verses, quite as strict as the symmetries or rhythm of the architecture, & a thousand times more beautiful, but there is something else than rhythm. The verses were neither made to order, nor to match, as the capitals were; & we have therefore a kind of pleasure in them other than a sense of propriety. But it requires a strong effort of common sense to shake ourselves quit of all that we have been taught for the last two centuries, and wake to the perception of a truth just as simple and certain as it is new: that great art, whether expressing itself in words, colours, or stones, does not say the same thing over and over again; that the merit of architectural, as of every other art, consists in its saying new and different things; that to repeat itself is no more a characteristic of genius in marble than it is of genius in print; and that we may, without offending any laws of good taste, require of an architect, as we do of a novelist, that he should be not only correct, but entertaining. ❡ Yet all this is true, & selfevident; only hidden from us, as many other selfevident things are, by false teaching. Nothing is a great work of art, for the production of which either rules or models can be given. Exactly so far as architecture works

on known rules, and from given models, it is not
an art, but a manufacture; & it is, of the two pro-
cedures, rather less rational (because more easy)
to copy capitals or mouldings from Phidias, and
call ourselves architects, than to copy heads and
hands from Titian and call ourselves painters.

ET us then understand at once that
change or variety is as much a ne-
cessity to the human heart & brain
in buildings as in books; that there
is no merit, though there is some oc-
casional use, in monotony; and that
we must no more expect to derive either pleasure
or profit from an architecture whose ornaments
are of one pattern, and whose pillars are of one
proportion, than we should out of a universe in
which the clouds were all of one shape, and the
trees all of one size.

ND this we confess in deeds, though
not in words. All the pleasure which
the people of the nineteenth cen-
tury take in art, is in pictures, sculp-
ture, minor objects of virtu or me-
diæval architecture, which we enjoy
under the term picturesque: no pleasure is taken
anywhere in modern buildings, & we find all men
of true feeling delighting to escape out of modern
cities into natural scenery: hence, as I shall here-
after show, that peculiar love of landscape which
is characteristic of the age. It would be well, if, in

38

all other matters, we were as ready to put up with
what we dislike, for the sake of compliance with
established law, as we are in architecture.

OW so debased a law ever came to be established, we shall see when we come to describe the Renaissance schools; here we have only to note, as a second most essential element of the Gothic spirit, that it broke through that law wherever it found it in existence; it not only dared, but delighted in, the infringe-ment of every servile principle; and invented a series of forms of which the merit was, not merely that they were new, but that they were capable of perpetual novelty. The pointed arch was not merely a bold variation from the round, but it ad-mitted of millions of variations in itself; for the proportions of a pointed arch are changeable to infinity, while a circular arch is always the same. The grouped shaft was not merely a bold varia-tion from the single one, but it admitted of mil-lions of variations in its grouping, and in the pro-portions resultant from its grouping. The intro-duction of tracery was not only a startling change in the treatment of window lights, but admitted endless changes in the interlacement of the trac-ery bars themselves. So that, while in all living Christian architecture the love of variety exists, the Gothic schools exhibited that love in culmi-nating energy; and their influence, wherever it

extended itself, may be sooner and farther traced by this character than by any other; the tendency to the adoption of Gothic types being always first shown by greater irregularity and richer variation in the forms of the architecture it is about to sup-ersede, long before the appearance of the pointed arch or of any other recognizable outward sign of the Gothic mind.

E must, however, herein note care-fully what distinction there is be-tween a healthy and a diseased love of change; for as it was in healthy love of change that the Gothic ar-chitecture rose, it was partly in con-sequence of diseased love of change that it was destroyed. In order to understand this clearly, it will be necessary to consider the different ways in which change and monotony are presented to us in nature; both having their use, like darkness & light, & the one incapable of being enjoyed with-out the other: change being most delightful after some prolongation of monotony, as light appears most brilliant after the eyes have been for some time closed.

BELIEVE that the true relations of monotony and change may be most simply understood by ob-serving them in music. We may therein notice, first, that there is a sublimity & majesty in monotony which there is not in rapid or frequent variation.

This is true throughout all nature. The greater part of the sublimity of the sea depends on its mo-notony; so also that of desolate moor & mountain scenery; and especially the sublimity of motion, as in the quiet, unchanged fall and rise of an en-gine beam. So also there is sublimity in darkness which there is not in light.

GAIN, monotony, after a certain time, or beyond a certain degree, becomes either uninteresting or in-tolerable, & the musician is oblig-ed to break it in one of two ways: either while the air or passage is perpetually repeated, its notes are variously en-riched & harmonized; or else, after a certain num-ber of repeated passages, an entirely new passage is introduced, which is more or less delightful ac-cording to the length of the previous monotony. Nature, of course, uses both these kinds of varia-tion perpetually. The sea-waves, resembling each other in general mass, but none like its brother in minor divisions and curves, are a monotony of the first kind; the great plain, broken by an emergent rock or clump of trees, is a monotony of the second.

ARTHER: in order to the enjoy-ment of the change in either case, a certain degree of patience is requir-ed from the hearer or observer. In the first case, he must be satisfied to endure with patience the recurrence of the great masses of sound or form, & to seek for

entertainment in a careful watchfulness of the
minor details. In the second case, he must bear
patiently the infliction of the monotony for some
moments, in order to feel the full refreshment of
the change. This is true even of the shortest mu-
sical passage in which the element of monotony
is employed. In cases of more majestic monotony,
the patience required is so considerable that it
becomes a kind of pain, a price paid for the future
pleasure.

GAIN: the talent of the composer
is not in the monotony, but in the
changes: he may show feeling and
taste by his use of monotony in cer-
tain places or degrees; that is to
say, by his various employment of
it; but it is always in the new arrangement or in-
vention that his intellect is shown, and not in the
monotony which relieves it. ⁋ Lastly: if the plea-
sure of change be too often repeated, it ceases to be
delightful, for then change itself becomes mono-
tonous, and we are driven to seek delight in ex-
treme and fantastic degrees of it. This is the dis-
eased love of change of which we have above
spoken.

ROM these facts we may gather
generally that monotony is, and
ought to be, in itself painful to us,
just as darkness is: that an archi-
tecture which is altogether monoto-
nous is a dark or dead architecture;

42

and of those who love it, it may be truly said, "they
love darkness rather than light." But monotony in
certain measure, used in order to give value to
change, and above all, that transparent monotony,
which, like the shadows of a great painter, suffers
all manner of dimly suggested form to be seen
through the body of it, is an essential in architec-
tural as in all other composition; & the endurance
of monotony has about the same place in a healthy
mind that the endurance of darkness has: that is to
say, as a strong intellect will have pleasure in the
solemnities of storm & twilight, and in the broken
and mysterious lights that gleam among them,
rather than in mere brilliancy and glare, while a
frivolous mind will dread the shadow and the
storm; and as a great man will be ready to endure
much darkness of fortune in order to reach greater
eminence of power or felicity, while an inferior
man will not pay the price; exactly in like manner
a great mind will accept, or even delight in, mono-
tony which would be wearisome to an inferior in-
tellect, because it has more patience and power of
expectation, and is ready to pay the full price for
the great future pleasure of change. But in all cases
it is not that the noble nature loves monotony,
any more than it loves darkness or pain. But it
can bear with it, and receive a high pleasure in the
endurance or patience, a pleasure necessary to the
well-being of this world; while those who will not
submit to the temporary sameness, but rush from

43

one change to another, gradually dull the edge of
change itself, and bring a shadow and weariness
over the whole world from which there is no more
escape.

ROM these general uses of variety in
the economy of the world, we may
at once understand its use and abuse
in architecture. The variety of the
Gothic schools is the more healthy
and beautiful, because in many cases
it is entirely unstudied, and results, not from
mere love of change, but from practical necessities.
For in one point of view Gothic is not only the
best, but the only rational architecture, as being
that which can fit itself most easily to all services,
vulgar or noble. Undefined in its slope of roof,
height of shaft, breadth of arch, or disposition of
ground plan, it can shrink into a turret, expand
into a hall, coil into a staircase, or spring into a
spire, with undegraded grace and unexhausted
energy; and whenever it finds occasion for change
in its form or purpose, it submits to it without the
slightest sense of loss either to its unity or majesty;
subtle and flexible like a fiery serpent, but ever
attentive to the voice of the charmer. And it is one
of the chief virtues of the Gothic builders, that they
never suffered ideas of outside symmetries & con-
sistencies to interfere with the real use and value
of what they did. If they wanted a window, they
opened one; a room, they added one; a buttress,

44

they built one; utterly regardless of any estab- ness

they built one; utterly regardless of any estab- Changeful-
lished conventionalities of external appearance, ness
knowing (as indeed it always happened) that
such daring interruptions of the formal plan would
rather give additional interest to its symmetry
than injure it. So that, in the best times of Gothic,
a useless window would rather have been opened
in an unexpected place for the sake of the surprise,
than a useful one forbidden for the sake of sym-
metry. Every successive architect, employed upon
a great work, built the pieces he added in his own
way, utterly regardless of the style adopted by his
predecessors; and if two towers were raised in
nominal correspondence at the sides of a cathedral
front, one was nearly sure to be different from the
other, and in each the style at the top to be dif- See Appendix
ferent from the style at the bottom. Note B.

THESE marked variations were,
however, only permitted as part
of the great system of perpetual
change which ran through every
member of Gothic design, and ren-
dered it as endless a field for the
beholder's enquiry as for the builder's imagina-
tion: change, which in the best schools is subtle
and delicate, and rendered more delightful by in-
termingling of a noble monotony; in the more
barbaric schools is somewhat fantastic and redun-
dant; but, in all, a necessary & constant condition
of the life of the school. Sometimes the variety is

45

in one feature, sometimes in another; it may be
in the capitals or crockets, in the niches or the
traceries, or in all together, but in some one or
other of the features it will be found always. If
the mouldings are constant, the surface sculpture
will change; if the capitals are of a fixed design,
the traceries will change; if the traceries are mono-
tonous, the capitals will change; and if even, as in
some fine schools, the early English for example,
there is the slightest approximation to an un-
varying type of mouldings, capitals, and floral
decoration, the variety is found in the disposition
of the masses, and in the figure sculpture.

I MUST now refer for a moment,
before we quit the consideration
of this, the second mental element
of Gothic, to the opening of the
third chapter of the Seven Lamps
of Architecture, in which the dis-
tinction was drawn between man gathering and
man governing; between his acceptance of the
sources of delight from nature, and his develop-
ment of authoritative or imaginative power in
their arrangement: for the two mental elements,
not only of Gothic, but of all good architecture,
which we have just been examining, belong to it,
and are admirable in it, chiefly as it is, more than
any other subject of art, the work of man, and the
expression of the average power of man. A picture
or poem is often little more than a feeble utterance

of man's admiration of something out of himself;
but architecture approaches more to a creation of
his own, born of his necessities, and expressive of
his nature. ❡ It is also, in some sort, the work of
the whole race, while the picture or statue is the
work of one only, in most cases more highly gifted
than his fellows. And therefore we may expect
that the first two elements of good architecture
should be expressive of some great truths com-
monly belonging to the whole race, and necessary
to be understood or felt by them in all their work
that they do under the sun. And observe what
they are: the confession of Imperfection, and the
confession of Desire of Change. The building of
the bird and the bee needs not express anything
like this. It is perfect and unchanging. ❡ But just
because we are something better than birds or
bees, our building must confess that we have not
reached the perfection we can imagine, and cannot
rest in the condition we have attained. If we pre-
tend to have reached either perfection or satisfac-
tion, we have degraded ourselves and our work.
God's work only may express that; but ours may
never have that sentence written upon it, "And
behold, it was very good." And, observe again, it
is not merely as it renders the edifice a book of
various knowledge, or a mine of precious thought,
that variety is essential to its nobleness. The vital
principle is not the love of Knowledge, but the
love of Change. It is that strange disquietude of

47

the Gothic spirit that is its greatness; that rest-
lessness of the dreaming mind, that wanders
hither and thither among the niches, and flickers
feverishly around the pinnacles and frets & fades
in labyrinthine knots & shadows along wall and
roof, and yet is not satisfied, nor shall be satisfied.
The Greek could stay in his triglyph furrow, and
be at peace; but the work of the Gothic art is fret-
work still, and it can neither rest in, nor from, its
labour, but must pass on, sleeplessly, until its love
of change shall be pacified for ever in the change
that must come alike on them that wake and them
that sleep.

HE third constituent
element of the Gothic
mind was stated to be
NATURALISM;
that is to say, the love of
natural objects for their
own sake, and the effort
to represent them frank-
ly, unconstrained by
artistical laws. ❡ This
characteristic of the style partly follows in neces-
sary connection with those named above. For,
so soon as the workman is left free to represent
what subjects he chooses, he must look to the na-
ture that is round him for material, and will en-
deavour to represent it as he sees it, with more or
less accuracy according to the skill he possesses,

48

and with much play of fancy, but with small reNaturalism
spect for law. There is, however, a marked dis/
tinction between the imaginations of the Western
and Eastern races, even when both are left free;
the Western, or Gothic, delighting most in the re/
presentation of facts, and the Eastern (Arabian,
Persian, and Chinese) in the harmony of colours
and forms. Each of these intellectual dispositions
has its particular forms of error and abuse, which,
though I have often before stated, I must here
again briefly explain; and this the rather, because
the word Naturalism is, in one of its senses, justly
used as a term of reproach, and the questions re/
specting the real relations of art and nature are so
many & so confused throughout all the schools of
Europe at this day, that I cannot clearly enunciate
any single truth without appearing to admit, in
fellowship with it, some kind of error, unless the
reader will bear with me in entering into such an
analysis of the subject as will serve us for general
guidance.

E are to remember, in the first place,
that the arrangement of colours
and lines is an art analogous to the
composition of music, and entirely See Appendix
independent of the representation Note C.
of facts. Good colouring does not
necessarily convey the image of anything but it/
self. It consists in certain proportions & arrange/
ments of rays of light, but not in likenesses to any/

49 e 1

thing. A few touches of certain greys and purples laid by a master's hand on white paper will be good colouring; as more touches are added beside them, we may find out that they were intended to re-present a dove's neck, and we may praise, as the drawing advances, the perfect imitation of the dove's neck. But the good colouring does not con-sist in that imitation, but in the abstract qualities and relations of the grey and purple. ⁋ In like manner, as soon as a great sculptor begins to shape his work out of the block, we shall see that its lines are nobly arranged, and of noble character. We may not have the slightest idea for what the forms are intended, whether they are of man or beast, of vegetation or drapery. Their likeness to anything does not affect their nobleness. They are magni-ficent forms, and that is all we need care to know of them, in order to say whether the workman is a good or bad sculptor.

OW the noblest art is an exact unison of the abstract value, with the imitative power, of forms and colours. It is the noblest composi-tion, used to express the noblest facts. But the human mind cannot in general unite the two perfections: it either pur-sues the fact to the neglect of the composition, or pursues the composition to the neglect of the fact.

ND it is intended by the Deity Naturalism that it should do this: the best art is not always wanted. Facts are often wanted without art, as in a geolog, ical diagram; and art often without facts, as in a Turkey carpet. And most men have been made capable of giving either one or the other, but not both; only one or two, the very highest, can give both. ⁅ Observe then. Men are universally divided, as respects their artistical qualifications, into three great classes; a right, a left, and a centre. On the right side are the men of facts, on the left the men of design, in the centre See Appendix the men of both. ⁅ The three classes of course Note D. pass into each other by imperceptible gradations. The men of facts are hardly ever altogether with, out powers of design; the men of design are al, ways in some measure cognizant of facts; and as each class possesses more or less of the powers of the opposite one, it approaches to the character of the central class. Few men, even in that central rank, are so exactly throned on the summit of the crest that they cannot be perceived to incline in the least one way or the other, embracing both hori, zons with their glance. Now each of these classes has, as I above said, a healthy function in the world, and correlative diseases or unhealthy func, tions; and, when the work of either of them is seen in its morbid condition, we are apt to find fault with the class of workmen, instead of finding fault

only with the particular abuse which has pervert/
ed their action.

ET us first take an instance of the healthy action of the three classes on a simple subject, so as fully to under/stand the distinction between them, and then we shall more easily ex/amine the corruptions to which they are liable. Fig: 1 in Plate VI. is a spray of vine with a bough of cherry/tree, which I have outlined from nature as accurately as I could, without in the least endeavouring to compose or arrange the form. It is a simple piece of fact/work, healthy and good as such, and useful to any one who wanted to know plain truths about tendrils of vines, but there is no attempt at design in it. Plate XIX., below, repre/sents a branch of vine used to decorate the angle of the Ducal Palace. It is faithful as a representa/tion of vine, and yet so designed that every leaf serves an architectural purpose, and could not be spared from its place without harm. This is cen/tral work; fact and design together. Fig: 2 in Plate VI. is a spandril from St. Mark's in which the forms of the vine are dimly suggested, the object of the design being merely to obtain graceful lines & well/proportioned masses upon the gold ground. There is not the least attempt to inform the spec/tator of any facts about the growth of the vine; there are no stalks or tendrils, merely running bands with leaves emergent from them, of which

nothing but the outline is taken from the vine, &
even that imperfectly. This is design, unregardful
of facts. ❡ Now the work is, in all these three
cases, perfectly healthy. Fig: 1 is not bad work be-
cause it has not design, nor Fig: 2 bad work because
it has not facts. The object of the one is to give plea-
sure through truth, and of the other to give plea-
sure through composition. And both are right.
❡ What, then, are the diseased operations to
which the three classes of workmen are liable?
RIMARILY, two; affecting the
two inferior classes;
1st, When either of those two classes
Despises the other;
2nd, When either of the two classes
Envies the other;
producing, therefore, four forms of dangerous error.
❡ First, when the men of facts despise design.
This is the error of the common Dutch painters,
of merely imitative painters of still life, flowers,
etc., and other men who, having either the gift of
accurate imitation or strong sympathies with na-
ture, suppose that all is done when the imitation
is perfected or sympathy expressed. A large body
of English landscapists come into this class, in-
cluding most clever sketchers from nature, who
fancy that to get a sky of true tone, and a gleam of
sunshine or sweep of shower faithfully expressed,
is all that can be required of art. These men are
generally themselves answerable for much of their

e 3

Naturalism deadness of feeling to the higher qualities of com/position. They probably have not originally the high gifts of design, but they lose such powers as they originally possessed by despising, & refusing to study, the results of great power of design in others. Their knowledge, as far as it goes, being accurate, they are usually presumptuous and self/conceited, and gradually become incapable of ad/miring anything but what is like their own works. They see nothing in the works of great designers but the faults, and do harm almost incalculable in the European society of the present day by sneer/ing at the compositions of the greatest men of the See Appendix Note F. earlier ages, because they do not absolutely tally with their own ideas of "Nature."

THE second form of error is when the men of design despise facts. All noble design must deal with facts to a certain extent, for there is no food for it but in nature. The best colourist invents best by taking hints from natural colours; from birds, skies, or groups of figures. And if, in the delight of invent/ing fantastic colour and form, the truths of nature are wilfully neglected, the intellect becomes com/paratively decrepit, and that state of art results which we find among the Chinese. The Greek de/signers delighted in the facts of the human form, and became great in consequence; but the facts of lower nature were disregarded by them, and their

inferior ornament became, therefore, dead and Naturalism valueless.

HE third form of error is when the men of facts envy design; that is to say, when, having only imitative powers, they refuse to employ those powers upon the visible world around them; but, having been taught that composition is the end of art, strive to obtain the inventive powers which nature has denied them, study nothing but the works of reputed designers, and perish in a fungous growth of plagiarism & laws of art. ❡ Here was the great error of the beginning of this century; it is the error of the meanest kind of men that employ themselves in painting, and it is the most fatal of all, rendering those who fall into it utterly useless, incapable of helping the world with either truth or fancy, while, in all probability, they deceive it by base resemblances of both, until it hardly recognizes truth or fancy when they really exist.

HE fourth form of error is when the men of design envy facts; that is to say, when the temptation of closely imitating nature leads them to forget their own proper ornamental function, and when they lose the power of the composition for the sake of graphic truth; as, for instance, in the hawthorn moulding so often spoken of round the porch of

55 e 4

Bourges Cathedral, which, though very lovely, might perhaps, as we saw above, have been better, if the old builder, in his excessive desire to make it look like hawthorn, had not painted it green.

IT is, however, carefully to be noted, that the two morbid conditions to which the men of facts are liable are much more dangerous & harmful than those to which the men of design are liable. The morbid state of men of design injures themselves only; that of the men of facts injures the whole world. The Chinese porcelain-painter is, indeed, not so great a man as he might be, but he does not want to break everything that is not porcelain : but the modern English fact-hunter, despising design, wants to destroy everything that does not agree with his own notions of truth, and becomes the most dangerous and despicable of iconoclasts, excited by egotism instead of religion. Again: the Bourges sculptor, painting his hawthorns green, did indeed somewhat hurt the effect of his own beautiful design, but did not prevent anyone from loving hawthorn: but Sir George Beaumont, trying to make Constable paint grass brown instead of green, was setting himself between Constable and nature, blinding the painter, and blaspheming the work of god.

S O much, then, of the diseases of the inferior classes, caused by their en-vying or despising each other. It is evident that the men of the central class cannot be liable to any morbid operation of this kind, they pos-sessing the powers of both. ❡ But there is another order of diseases which affect all the three classes, considered with respect to their pursuit of facts. For observe, all the three classes are in some de-gree pursuers of facts; even the men of design not being in any case altogether independent of exter-nal truth. Now, considering them all as more or less searchers after truth, there is another triple division to be made of them. Everything pre-sented to them in nature has good and evil min-gled in it: and artists, considered as searchers after truth, are again to be divided into three great classes, a right, a left, and a centre. Those on the right perceive, and pursue, the good, and leave the evil: those in the centre, the greatest, perceive and pursue the good and evil together, the whole thing as it verily is: those on the left perceive and pursue the evil and leave the good.

T HE first class, I say, take the good and leave the evil. But of whatever is presented to them, they gather what it has of grace, and life, and light, and holiness, and leave all, or at least as much as possible, of the rest undrawn. The faces of their figures express

57

Naturalism no evil passions; the skies of their landscapes are without storm ; the prevalent character of their colour is brightness, & of their chiaroscuro fulness of light. The early Italian and Flemish painters, Angelico and Memling, Perugino, Francia, Raf-faelle in his best time, John Bellini, and our own Stothard, belong eminently to this class.

THE second, or greatest class, ren-der all that they see in nature un-hesitatingly, with a kind of divine grasp & government of the whole, sympathizing with all the good, and yet confessing, permitting, & bringing good out of the evil also. Their subject is infinite as nature, their colour equally balanced between splendour and sadness, reaching occa-sionally the highest degrees of both, & their chia-roscuro equally balanced between light & shade. ❡ The principal men of this class are Michael Angelo, Leonardo, Giotto, Tintoret, & Turner. Raffaelle in his second time, Titian, and Rubens are transitional; the first inclining to the eclectic, and the last two to the impure class, Raffaelle rarely giving all the evil, Titian and Rubens rarely all the good.

THE last class perceive and imitate evil only. They cannot draw the trunk of a tree without blasting and shattering it, nor a sky except covered with stormy clouds; they delight in the beggary & brutality

of the human race; their colour is for the most
part subdued or lurid, and the greater spaces of
their pictures are occupied by darkness. ❡ Hap-
pily the examples of this class are seldom seen
in perfection. Salvator Rosa and Caravaggio are
the most characteristic: the other men belong-
ing to it approach towards the central rank by
imperceptible gradations, as they perceive and
represent more and more of good. But Murillo,
Zurbaran, Camillo Procaccini, Rembrandt, and
Teniers, all belong naturally to this lower class.
NOW, observe: the three classes in-
to which artists were previously
divided, of men of fact, men of de-
sign, and men of both, are all of
Divine institution, but of these
latter three, the last is in nowise of
Divine institution. It is entirely human, and the
men who belong to it have sunk into it by their
own faults. They are, so far forth, either useless or
harmful men. It is indeed good that evil should be
occasionally represented, even in its worst forms,
but never that it should be taken delight in: and
the mighty men of the central class will always
give us all that is needful of it; sometimes, as
Hogarth did, dwelling upon it bitterly as satirists;
but this with the more effect, because they will
neither exaggerate it, nor represent it mercilessly,
and without the atoning points that all evil shows
to a Divinely guided glance, even at its deepest.

59

So then, though the third class will always, I fear, in some measure exist, the two necessary classes are only the first two: and this is so far acknow-ledged by the general sense of men, that the basest class has been confounded with the second; and painters have been divided commonly only into two ranks, now known, I believe, throughout Europe by the names which they first received in Italy, "Puristi and Naturalisti." Since, however, in the existing state of things, the degraded or evil-loving class, though less defined than that of the Puristi, is just as vast as it is indistinct, this division has done infinite dishonour to the great faithful painters of nature: & it has long been one of the objects I have had most at heart to show that, in reality, the Purists, in their sanctity, are less separated from these natural painters than the Sensualists in their foulness; and that the differ-ence, though less discernible, is in reality greater, between the man who pursues evil for its own sake, and him who bears with it for the sake of truth, than between this latter and the man who will not endure it at all.

ET us, then, endeavour briefly to mark the real relations of these three vast ranks of men, whom I shall call, for convenience in speaking of them, Purists, Naturalists, and Sensua-lists; not that these terms express their real characters, but I know no word, & can-

not coin a convenient one, which would accurately
express the opposite of Purist; & I keep the terms
Purist and Naturalist in order to comply, as far as
possible, with the established usage of language
on the Continent. Now, observe: in saying that
nearly everything presented to us in nature has
mingling in it of good and evil, I do not mean that
nature is conceivably improvable, or that any-
thing that God has made could be called evil, if we
could see far enough into its uses, but that with
respect to immediate effects or appearances, it may
be so, just as the hard rind or bitter kernel of a fruit
may be an evil to the eater, though in the one is the
protection of the fruit, and in the other its con-
tinuance. The Purist, therefore, does not mend
nature, but receives from nature & from God that
which is good for him; while the Sensualist fills
himself "with the husks that the swine did eat."
❡ The three classes may, therefore, be likened to
men reaping wheat, of which the Purists take the
fine flour, and the Sensualists the chaff and straw,
but the Naturalists take all home, and make their
cake of one, and their couch of the other.

OR instance. We know more cer-
tainly every day that whatever ap-
pears to us harmful in the universe
has some beneficent or necessary
operation; that the storm which de-
stroys a harvest brightens the sun-
beams for harvests yet unsown, & that the volcano
which buries a city preserves a thousand from de-

61

struction.Buttheevilisnotforthetimelessfearful, because we have learned it to be necessary; and we easily understand the timidity or the tenderness of the spirit which would withdraw itself from the presence of destruction, and create in its imagina- tion a world of which the peace should be unbrok- en, in which the sky should not darken nor the sea rage, in which the leaf should not change nor the blossom wither. That man is greater, however, who contemplates with an equal mind the alterna- tions of terror & of beauty; who not rejoicing less beneath the sunny sky, can bear also to watch the bars of twilight narrowing on the horizon; and, not less sensible to the blessing of the peace of nature, can rejoice in the magnificence of the ordinances by which that peace is protected and secured. But separated from both by an immeas- urable distance would be the man who delighted in convulsion and disease for their own sake; who found his daily food in the disorder of nature mingled with the suffering of humanity; and watched joyfully at the right hand of the Angel whose appointed work is to destroy as well as to accuse, while the corners of the house of feasting were struck by the wind from the wilderness.

ND far more is this true, when the subject of contemplation is human- ity itself. The passions of mankind are partly protective, partly benefi- cent, like the chaff and grain of the corn; but none without their use,

none without nobleness when seen in balanced Naturalism
unity with the rest of the spirit which they are
charged to defend. The passions of which the end
is the continuance of the race: the indignation
which is to arm it against injustice, or strengthen
it to resist wanton injury; and the fear which lies See Appendix
at the root of prudence, reverence, and awe, are all Note G.
honourable and beautiful, so long as man is re-
garded in his relations to the existing world. The
religious Purist, striving to conceive him with-
drawn from those relations, effaces from the coun-
tenance the traces of all transitory passion, illu-
mines it with holy hope and love, and seals it with
the serenity of heavenly peace; he conceals the
forms of the body by the deep-folded garment,
or else represents them under severely chastened
types, and would rather paint them emaciated by
the fast, or pale from the torture, than strengthened
by exertion, or flushed by emotion. But the great
Naturalist takes the human being in its whole-
ness, in its mortal as well as its spiritual strength.
Capable of sounding and sympathizing with the
whole range of its passions, he brings one majestic
harmony out of them all; he represents it fear-
lessly in all its acts and thoughts, in its haste, its
anger, its sensuality, and its pride, as well as in its
fortitude or faith, but makes it noble in them all;
he casts aside the veil from the body, and beholds
the mysteries of its form like an angel looking
down on an inferior creature: there is nothing

63

Naturalism which he is reluctant to behold, nothing that he is ashamed to confess; with all that lives, triumphing, falling, or suffering, he claims kindred, either in majesty or in mercy, yet standing, in a sort, afar off, unmoved even in the deepness of his sympathy; for the spirit within him is too thoughtful to be grieved, too brave to be appalled, and too pure to be polluted.

OW far beneath these two ranks of men shall we place, in the scale of being, those whose pleasure is only in sin or in suffering; who habitually contemplate humanity in poverty or decrepitude, fury or sensuality; whose works are either temptations to its weakness, or triumphs over its ruin, and recognize no other subjects for thought or admiration than the subtlety of the robber, the rage of the soldier, or the joy of the Sybarite? It seems strange, when thus definitely stated, that such a school should exist. Yet consider a little what gaps and blanks would disfigure our gallery and chamber walls, in places that we have long approached with reverence, if every picture, every statue, were removed from them, of which the subject was either the vice or the misery of mankind, portrayed without any moral purpose; consider the innumerable groups having reference merely to various forms of passion, low or high: drunken revels & brawls among peasants, gambling or fighting scenes among sol-

diers, amours and intrigues among every class,
brutal battle pieces, banditti subjects, gluts of tor,
ture and death in famine, wreck, or slaughter, for
the sake merely of the excitement, that quicken,
ing and suppling of the dull spirit that cannot be
gained for it but by bathing it in blood, afterward
to wither back into stained and stiffened apathy;
and then that whole vast false heaven of sensual
passion, full of nymphs, satyrs, graces, goddesses,
and I know not what, from its high seventh circle
in Correggio's Antiope, down to the Grecized
ballet,dancers & smirking Cupids of the Parisian
upholsterer. Sweep away all this, remorselessly,
and see how much art we should have left.

AND yet these are only the grossest
manifestations of the tendency of
the school. There are subtler, yet
not less certain, signs of it in the
works of men who stand high in
the world's list of sacred painters.
I doubt not that the reader was surprised when I
named Murillo among the men of this third rank.
Yet, go into the Dulwich Gallery, and meditate
for a little over that much celebrated picture of the
two beggar boys, one eating, lying on the ground,
the other standing beside him. We have among
our own painters one who cannot indeed be set
beside Murillo as a painter of Madonnas, for he is
a pure Naturalist, and, never having seen a Ma,
donna, does not paint any; but who, as a painter

of beggar or peasant boys, may be set beside Murillo, or any one else, W. Hunt. He loves peasant boys, because he finds them more roughly and picturesquely dressed, & more healthily coloured, than others. And he paints all that he sees in them fearlessly; all the health and humour, and freshness & vitality, together with such awkwardness and stupidity, & what else of negative or positive harm there may be in the creature; but yet so that on the whole we love it, and find it perhaps even beautiful, or if not, at least we see that there is capability of good in it, rather than of evil; and all is lighted up by a sunshine and sweet colour that makes the smock frock as precious as cloth of gold. But look at those two ragged and vicious vagrants that Murillo has gathered out of the street. You smile at first, because they are eating so naturally, and their roguery is so complete. But is there anything else than roguery there, or was it well for the painter to give his time to the painting of those repulsive & wicked children? Do you feel moved with any charity towards children as you look at them? Are we the least more likely to take any interest in ragged schools, or to help the next pauper child that comes in our way, because the painter has shown us a cunning beggar feeding greedily? Mark the choice of the act. He might have shown hunger in other ways, and given interest to even this act of eating, by making the face wasted, or the eye wistful. But he did not care to do this. He

66

delighted merely in the disgusting manner of eat,
ing, the food filling the cheek; the boy is not hun,
gry, else he would not turn round to talk and grin
as he eats.

BUT observe another point in the lower figure. It lies so that the sole of the foot is turned towards the spectator; not because it would have lain less easily in another at, titude, but that the painter may draw, and exhibit, the grey dust engrained in the foot. Do not call this the painting of nature: it is mere delight in foulness. The lesson, if there be any, in the picture, is not one whit the stronger. We all know that a beggar's bare foot cannot be clean; there is no need to thrust its degradation into the light, as if no human imagination were vigorous enough for its conception.

THE position of the Sensualists, in treatment of landscape, is less distinctly marked than in that of the figure, because even the wild, est passions of nature are noble: but the inclination is manifested by carelessness in marking generic form in trees and flowers: by their preferring confused and ir, regular arrangements of foliage or foreground to symmetrical & simple grouping; by their general choice of such picturesqueness as results from de, cay, disorder, & disease, rather than of that which

Naturalism is consistent with the perfection of the things in which it is found; and by their imperfect rendering of the elements of strength and beauty in all things. I propose to work out this subject fully in the last volume of Modern Painters; but I trust that enough has been here said to enable the reader to understand the relations of the three great classes of artists, and therefore also the kinds of morbid condition into which the two higher (for the last has no other than a morbid condition) are liable to fall. For, since the function of the Naturalists is to represent, as far as may be, the whole of nature, and of the Purists to represent what is absolutely good for some special purpose or time, it is evident that both are liable to err from shortness of sight, and the last also from weakness of judgment. I say, in the first place, both may err from shortness of sight, from not seeing all that there is in nature; seeing only the outside of things, or those points of them which bear least on the matter in hand. ❡ For instance, a modern continental Naturalist sees the anatomy of a limb thoroughly, but does not see its colour against the sky, which latter fact is to a painter far the more important of the two. And because it is always easier to see the surface than the depth of things, the full sight of them requiring the highest powers of penetration, sympathy, and imagination, the world is full of vulgar Naturalists: not Sensualists, observe, not men who delight in evil; but men

68

who never see the deepest good, and who bring Naturalism
discredit on all painting of Nature by the little
that they discover in her. And the Purist, besides
being liable to this same shortsightedness, is liable
also to fatal errors of judgment; for he may think
that good which is not so, and that the highest
good which is the least. And thus the world is
full of vulgar Purists, who bring discredit on all See Appendix
selection by the silliness of their choice; and this Note H.
the more, because the very becoming a Purist is
commonly indicative of some slight degree of
weakness, readiness to be offended, or narrow-
ness of understanding of the ends of things: the
greatest men being, in all times of art, Natural-
ists, without any exception; and the greatest Pu-
rists being those who approach nearest to the
Naturalists, as Benozzo Gozzoli and Perugino.
Hence there is a tendency in the Naturalists to
despise the Purists, & in the Purists to be offended
with the Naturalists (not understanding them,
and confounding them with the Sensualists); and
this is grievously harmful to both.

F the various forms of resultant
mischief it is not here the place to
speak; the reader may already be
somewhat wearied with a state-
ment which has led us apparently
so far from our immediate subject.
But the digression was necessary, in order that I
might clearly define the sense in which I use the

word Naturalism when I state it to be the third most essential characteristic of Gothic architecture. I mean that the Gothic builders belong to the central or greatest rank in both the classifications of artists which we have just made; that considering all artists as either men of design, men of facts, or men of both, the Gothic builders were men of both; and that again, considering all artists as either Purists, Naturalists, or Sensualists, the Gothic builders were Naturalists.

I SAY first, that the Gothic builders were of that central class which unites fact with design; but that the part of the work which was more especially their own was the truthfulness. Their power of artistical invention or arrangement was not greater than that of Romanesque & Byzantine workmen: by those workmen they were taught the principles, and from them received their models, of design; but to the ornamental feeling and rich fancy of the Byzantine the Gothic builder added a love of FACT which is never found in the South. Both Greek and Roman used conventional foliage in their ornament, passing into something that was not foliage at all, knotting itself into strange cuplike buds or clusters, and growing out of lifeless rods instead of stems; the Gothic sculptor received these types, at first, as things that ought to be, just as we have a second time received them; but he

could not rest in them. He saw there was no ve-
racity in them, no knowledge, no vitality. Do what
he would, he could not help liking the true leaves
better; and cautiously, a little at a time, he put
more of nature into his work, until at last it was
all true, retaining, nevertheless, every valuable
character of the original well-disciplined and de-
signed arrangement.

OR is it only in external and visi-
ble subject that the Gothic work-
man wrought for truth: he is as
firm in his rendering of imagina-
tive as of actual truth; that is to say,
when an idea would have been by
a Roman, or Byzantine, symbolically represent-
ed, the Gothic mind realizes it to the utmost. For
instance, the purgatorial fire is represented in the
mosaic of Torcello (Romanesque) as a red stream,
longitudinally striped like a riband, descending
out of the throne of Christ, and gradually extend-
ing itself to envelope the wicked. When we are
once informed what this means, it is enough for
its purpose; but the Gothic inventor does not leave
the sign in need of interpretation. He makes the
fire as like real fire as he can; and in the porch of
St. Maclou at Rouen the sculptured flames burst
out of the Hades gate, and flicker up, in writhing
tongues of stone, through the interstices of the
niches, as if the church itself were on fire. This is
an extreme instance, but it is all the more illus-

f 4

trative of the entire difference in temper & thought between the two schools of art, and of the intense love of veracity which influenced the Gothic design.

I DO not say that this love of veracity is always healthy in its operation. I have above noticed the errors into which it falls from despising design; and there is another kind of error noticeable in the instance just given, in which the love of truth is too hasty, and seizes on a surface truth instead of an inner one. For in representing the Hades fire, it is not the mere form of the flame which needs most to be told, but its unquenchableness, its Divine ordainment and limitation, & its inner fierceness, not physical and material, but in being the expression of the wrath of God. And these things are not to be told by imitating the fire that flashes out of a bundle of sticks. If we think over his symbol a little, we shall perhaps find that the Romanesque builder told more truth in that likeness of a blood-red stream, flowing between definite shores, and out of God's throne, & expanding, as if fed by a perpetual current, into the lake wherein the wicked are cast, than the Gothic builder in those torch-flickerings about his niches. But this is not to our immediate purpose; I am not at present to insist upon the faults into which the love of truth was led in the later Gothic times, but on

the feeling itself, as a glorious and peculiar char acteristic of the Northern builders. For, observe, it is not, even in the above instance, love of truth, but want of thought, which causes the fault. The love of truth, as such, is good, but when it is mis/ directed by thoughtlessness or over/excited by vanity, and either seizes on facts of small value, or gathers them chiefly that it may boast of its grasp and apprehension, its work may well become dull or offensive. Yet let us not, therefore, blame the inherent love of facts, but the incautiousness of their selection, and impertinence of their state/ ment.

SAID, in the second place, that Gothic work, when referred to the arrangement of all art, as purist, naturalist, or sensualist, was natu/ ralist. This character follows neces/ sarily on its extreme love of truth, prevailing over the sense of beauty, and causing it to take delight in portraiture of every kind, and to express the various characters of the human countenance and form, as it did the varieties of leaves and the ruggedness of branches. And this tendency is both increased and ennobled by the same Christian humility which we saw express/ ed in the first character of Gothic work, its rude/ ness. For as that resulted from a humility which confessed the imperfection of the workman, so this naturalist portraiture is rendered more faith/

73

Naturalism ful by the humility which confesses the imper/ fection of the subject. The Greek sculptor could neither bear to confess his own feebleness, nor to tell the faults of the forms that he portrayed. But the Christian workman, believing that all is final/ ly to work together for good, freely confesses both, and neither seeks to disguise his own roughness of work, nor his subject's roughness of make. Yet this frankness being joined, for the most part, with depth of religious feeling in other directions, and especially with charity, there is sometimes a ten/ dency to Purism in the best Gothic sculpture; so that it frequently reaches great dignity of form & tenderness of expression, yet never so as to lose the veracity of portraiture, wherever portraiture is possible: not exalting its kings into demi/gods, nor its saints into archangels, but giving what kingliness and sanctity was in them, to the full, mixed with due record of their faults; and this in the most part with a great indifference like that of Scripture history, which sets down, with un/ moved and unexcusing resoluteness, the virtues & errors of all men of whom it speaks, often leav/ ing the reader to form his own estimate of them, without an indication of the judgment of the his/ torian. And this veracity is carried out by the Go/ thic sculptors in the minuteness and generality, as well as the equity, of their delineation: for they do not limit their art to the portraiture of saints and kings, but introduce the most familiar scenes

74

and most simple subjects: filling up the back- Naturalism
grounds of Scripture histories with vivid & curi-
ous representations of the commonest incidents
of daily life, and availing themselves of every oc-
casion in which, either as a symbol, or an explana-
tion of a scene or time, the things familiar to the
eye of the workman could be introduced & made
of account. Hence Gothic sculpture and painting
are not only full of valuable portraiture of the
greatest men, but copious records of all the do-
mestic customs & inferior arts of the ages in which See Appendix
it flourished. Note I.

HERE is, however, one direction
in which the Naturalism of the
Gothic workmen is peculiarly ma-
nifested; and this direction is even
more characteristic of the school
than the Naturalism itself; I mean
their peculiar fondness for the forms of Vegetation.
In rendering the various circumstances of daily
life, Egyptian and Ninevite sculpture is as frank
and as diffuse as the Gothic. From the highest
pomps of state or triumphs of battle, to the most
trivial domestic arts and amusements, all is taken
advantage of to fill the field of granite with the
perpetual interest of a crowded drama; and the
early Lombardic and Romanesque sculpture is
equally copious in its description of the familiar
circumstances of war and the chase. But in all the
scenes portrayed by the workmen of these nations,

75

Naturalism vegetation occurs only as an explanatory acces-
sary; the reed is introduced to mark the course of
the river, or the tree to mark the covert of the wild
beast, or the ambush of the enemy, but there is no
especial interest in the forms of the vegetation
strong enough to induce them to make it a subject
of separate and accurate study. Again, among the
nations who followed the arts of design exclusively,
the forms of foliage introduced were meagre and
general, and their real intricacy & life were neither
admired nor expressed. But to the Gothic work-
man the living foliage became a subject of intense
affection, and he struggled to render all its char-
acters with as much accuracy as was compatible
with the laws of his design and the nature of his
material, not unfrequently tempted in his en-
thusiasm to transgress the one and disguise the
other. HERE is a peculiar significance
in this, indicative both of higher
civilization and gentler tempera-
ment, than had before been mani-
fested in architecture. Rudeness, &
the love of change, which we have
insisted upon as the first elements of Gothic, are
also elements common to all healthy schools. But
here is a softer element mingled with them, pecu-
liar to the Gothic itself. The rudeness or ignorance
which would have been painfully exposed in the
treatment of the human form, are still not so great

as to prevent the successful rendering of the way Naturalism
side herbage; & the love of change, which becomes
morbid and feverish in following the haste of the
hunter and the rage of the combatant, is at once
soothed and satisfied as it watches the wandering
of the tendril, and the budding of the flower. Nor
is this all: the new direction of mental interest
marks an infinite change in the means and the
habits of life. The nations whose chief support was
in the chase, whose chief interest was in the battle,
whose chief pleasure was in the banquet, would
take small care respecting the shapes of leaves and
flowers; and notice little in the forms of the forest
trees which sheltered them, except the signs indi-
cative of the wood which would make the toughest
lance, the closest roof, or the clearest fire. The af-
fectionate observation of the grace and outward
character of vegetation is the sure sign of a more
tranquil & gentle existence, sustained by the gifts,
and gladdened by the splendour, of the earth. In
that careful distinction of species, and richness of
delicate & undisturbed organization, which char-
acterize the Gothic design, there is the history of
rural and thoughtful life, influenced by habitual
tenderness, and devoted to subtle inquiry; and
every discriminating & delicate touch of the chisel,
as it rounds the petal or guides the branch, is a
prophecy of the development of the entire body
of the natural sciences, beginning with that of
medicine, of the recovery of literature, and the es-

77

tablishment of the most necessary principles of domestic wisdom and national peace.

I HAVE before alluded to the strange and vain supposition, that the original conception of Gothic architecture had been derived from vegetation, from the symmetry of avenues, and the interlacing of branches. It is a supposition which never could have existed for a moment in the mind of any person acquainted with early Gothic; but, however idle as a theory, it is most valuable as a testimony to the character of the perfected style. It is precisely because the reverse of this theory is the fact, because the Gothic did not arise out of, but develope itself into, a resemblance to vegetation, that this resemblance is so instructive as an indication of the temper of the builders. It was no chance suggestion of the form of an arch from the bending of a bough, but a gradual & continual discovery of a beauty in natural forms which could be more and more perfectly transferred into those of stone, that influenced at once the heart of the people, and the form of the edifice. The Gothic architecture arose in massy and mountainous strength, axe-hewn, and iron-bound, block heaved upon block by the monk's enthusiasm and the soldier's force; and cramped and stanchioned into such weight of grisly wall, as might bury the anchoret in darkness, and beat back the utmost storm of battle, suffering but by

78

the same narrow crosslet the passing of the sun⁄
beam, or of the arrow. Gradually, as that monkish
enthusiasm became more thoughtful, and as the
sound of war became more and more intermittent
beyond the gates of the convent or the keep, the
stony pillar grew slender & the vaulted roof grew
light, till they had wreathed themselves into the
semblance of the summer woods at their fairest,
and of the dead field⁄flowers, long trodden down
in blood, sweet monumental statues were set to
bloom for ever, beneath the porch of the temple,
or the canopy of the tomb.

NOR is it only as a sign of greater
gentleness or refinement of mind,
but as a proof of the best possible
direction of this refinement, that
the tendency of the Gothic to the
expression of vegetative life is to be
admired. That sentence of Genesis, "I have given
thee every green herb for meat," like all the rest of
the book, has a profound symbolical as well as a
literal meaning. It is not merely the nourishment
of the body, but the food of the soul, that is in⁄
tended. The green herb is, of all nature, that which
is most essential to the healthy spiritual life of
man. Most of us do not need fine scenery; the pre⁄
cipice & the mountain peak are not intended to be
seen by all men; perhaps their power is greatest
over those who are unaccustomed to them. But
trees and fields and flowers were made for all, and

are necessary for all. God has connected the labour which is essential to the bodily sustenance with the pleasures which are healthiest for the heart; and while He made the ground stubborn, He made its herbage fragrant, and its blossoms fair. The proudest architecture that man can build has no higher honour than to bear the image and recall the memory of that grass of the field which is, at once, the type & the support of his existence; the goodly building is then most glorious when it is sculptured into the likeness of the leaves of Para-dise; and the great Gothic spirit, as we showed it to be noble in its disquietude, is also noble in its hold of nature; it is, indeed, like the dove of Noah, in that she found no rest upon the face of the wa-ters, but like her in this also, "LO, IN HER MOUTH WAS AN OLIVE BRANCH, PLUCKED OFF."

HE fourth essential ele-ment of the Gothic mind was above stated to be the sense of the GRO-TESQUE; but I shall defer the endeavour to define this most curious & subtle character until we have occasion to ex-amine one of the divi-sions of the Renaissance schools, which was mor-bidly influenced by it. It is the less necessary to

insist upon it here, because every reader familiar
with Gothic architecture must understand what
I mean, and will, I believe, have no hesitation in
admitting that the tendency to delight in fantastic
and ludicrous, as well as in sublime, images, is a
universal instinct of the Gothic imagination.

HE fifth element above named was RIGIDITY; and this character I must endeavour carefully to define, for neither the word I have used, nor any other that I can think of, will express it accurately. For I mean, not merely stable, but active rigidity;
the peculiar energy which gives tension to movement, and stiffness to resistance, which makes the
fiercest lightning forked rather than curved, & the
stoutest oak-branch angular rather than bending,
and is as much seen in the quivering of the lance
as in the glittering of the icicle.

HAVE before had occasion to note some manifestations of this energy or fixedness; but it must be still more attentively considered here, as it shows itself throughout the whole structure & decoration
of Gothic work. Egyptian and Greek buildings
stand, for the most part, by their own weight and

Rigidity mass, one stone passively incumbent on another; but in the Gothic vaults & traceries there is a stiffness analogous to that of the bones of a limb, or fibres of a tree; an elastic tension and communication of force from part to part, & also a studious expression of this throughout every visible line of the building. And, in like manner, the Greek and Egyptian ornament is either mere surface engraving, as if the face of the wall had been stamped with a seal, or its lines are flowing, lithe, & luxuriant; in either case, there is no expression of energy in the framework of the ornament itself. But the Gothic ornament stands out in prickly independence, and frosty fortitude, jutting into crockets, & freezing into pinnacles; here starting up into a monster, there germinating into a blossom, anon knitting itself into a branch, alternately thorny, bossy, & bristly, or writhed into every form of nervous entanglement; but, even when most graceful, never for an instant languid, always quickset: erring, if at all, ever on the side of brusquerie.

THE feelings or habits in the workman which give rise to this character in the work, are more complicated and various than those indicated by any other sculptural expression hitherto named. There is, first, the habit of hard and rapid working; the industry of the tribes of the North, quickened by the coldness of the climate, and giving an expres-

sion of sharp energy to all they do, as opposed to
the languor of the Southern tribes, however much
of fire there may be in the heart of that languor, for
lava itself may flow languidly. There is also the
habit of finding enjoyment in the signs of cold,
which is never found, I believe, in the inhabitants
of countries south of the Alps. Cold is to them an
unredeemed evil, to be suffered and forgotten as
soon as may be; but the long winter of the North
forces the Goth (I mean the Englishman, French-
man, Dane, or German), if he would lead a hap-
py life at all, to find sources of happiness in foul
weather as well as fair, & to rejoice in the leafless
as well as in the shady forest. And this we do with
all our hearts; finding perhaps nearly as much
contentment by the Christmas fire as in the sum-
mer sunshine, & gaining health and strength on
the ice-fields of winter, as well as among the mea-
dows of spring. So that there is nothing adverse
or painful to our feelings in the cramped and stiff-
ened structure of vegetation checked by cold; and
instead of seeking, like the Southern sculptor, to
express only the softness of leafage nourished in
all tenderness, and tempted into all luxuriance by
warm winds and glowing rays, we find pleasure
in dwelling upon the crabbed, perverse, & morose
animation of plants that have known little kind-
ness from earth or heaven, but, season after sea-
son, have had their best efforts palsied by frost,
their brightest buds buried under snow, and their
goodliest limbs lopped by tempest.

HERE are many subtle sympa-
thies & affections which join to con-
firm the Gothic mind in this pecu-
liar choice of subject; and when we
add to the influence of these, the ne-
cessities consequent upon the em-
ployment of a rougher material, compelling the
workman to seek for vigour of effect, rather than
refinement of texture or accuracy of form, we have
direct and manifest causes for much of the differ-
ence between the northern and southern cast of
conception : but there are indirect causes holding
a far more important place in the Gothic heart,
though less immediate in their influence on de-
sign. Strength of will, independence of character,
resoluteness of purpose, impatience of undue con-
trol, and that general tendency to set the individual
reason against authority, and the individual deed
against destiny, which, in the Northern tribes, has
opposed itself throughout all ages to the languid
submission, in the Southern, of thought to tradi-
tion, & purpose to fatality, are all more or less trace-
able in the rigid lines, vigorous & various masses,
and daringly projecting & independent structure
of the Northern Gothic ornament: while the op-
posite feelings are in like manner legible in the
graceful and softly guided waves and wreathed
bands, in which Southern decoration is constantly
disposed; in its tendency to lose its independence,
and fuse itself into the surface of the masses upon

84

which it is traced; and in the expression seen so often, in the arrangement of those masses them, selves, of an abandonment of their strength to an inevitable necessity, or a listless repose.

THERE is virtue in the measure, & error in the excess, of both these characters of mind, and in both of the styles which they have created; the best architecture, and the best temper, are those which unite them both; and this fifth impulse of the Gothic heart is therefore that which needs most caution in its in, dulgence. ❡ It is more definitely Gothic than any other, but the best Gothic building is not that which is most Gothic: it can hardly be too frank in its confession of rudeness, hardly too rich in its changefulness, hardly too faithful in its natura, lism; but it may go too far in its rigidity, and, like the great Puritan spirit in its extreme, lose itself either in frivolity of division, or perversity of pur, pose. It actually did so in its later times; but it is See Appendix gladdening to remember that in its utmost noble, Note K. ness, the very temper which has been thought most adverse to it, the Protestant spirit of self, dependence & inquiry, was expressed in its every line. Faith and aspiration there were, in every Christian ecclesiastical building, from the first century to the fifteenth; but the moral habits to which England in this age owes the kind of great, ness that she has, the habits of philosophical in,

85 g 3

Redundance vestigation, of accurate thought, of domestic se, clusion and independence, of stern self-reliance and sincere upright searching into religious truth, were only traceable in the features which were the distinctive creation of the Gothic schools, in the veined foliage, and thorny fretwork, and shadowy niche, and buttressed pier, and fearless height of See Appendix Note L. subtle pinnacle & crested tower, sent like an "un-perplexed question up to Heaven."

AST, because the least essential, of the constitu, ent elements of this noble school, was placed that of REDUNDANCE, the uncalculating bestowal of the wealth of its labour. There is, indeed, much Gothic, & that of the best period, in which this ele, ment is hardly traceable, & which depends for its effect almost exclusively on loveliness of simple design and grace of uninvolved proportion: still, in the most characteristic buildings, a certain portion of their effect depends upon accumulation of orna, ment; & many of those which have most influence on the minds of men, have attained it by means of this attribute alone. And although, by careful study of the school, it is possible to arrive at a con, dition of taste which shall be better contented by a few perfect lines than by a whole facade covered

with fretwork, the building which only satisfies
such a taste is not to be considered the best. For
the very first requirement of Gothic architecture
being, as we saw above, that it shall both admit
the aid, and appeal to the admiration, of the rudest
as well as the most refined minds, the richness of
the work is, paradoxical as the statement may ap-
pear, a part of its humility. No architecture is so
haughty as that which is simple; which refuses to
address the eye, except in a few clear and forceful
lines; which implies, in offering so little to our re-
gards, that all it has offered is perfect; & disdains,
either by the complexity or the attractiveness of
its features, to embarrass our investigation, or be-
tray us into delight. That humility, which is the
very life of the Gothic school, is shown not only
in the imperfection, but in the accumulation, of
ornament. The inferior rank of the workman is
often shown as much in the richness, as the rough-
ness, of his work; and if the co-operation of every
hand, and the sympathy of every heart, are to be
received, we must be content to allow the redun-
dance which disguises the failure of the feeble, and
wins the regard of the inattentive. There are, how-
ever, far nobler interests mingling, in the Gothic
heart, with the rude love of decorative accumula-
tion: a magnificent enthusiasm which feels as if
it never could do enough to reach the fulness of its
ideal; an unselfishness of sacrifice, which would
rather cast fruitless labour before the altar than

Redundance stand idle in the market; and finally, a profound sympathy with the fulness & wealth of the material universe, rising out of that Naturalism whose operation we have already endeavoured to define. The sculptor who sought for his models among the forest leaves, could not but quickly and deeply feel that complexity need not involve the loss of grace, nor richness that of repose; and every hour which he spent in the study of the minute and various work of Nature, made him feel more forcibly the barrenness of what was best in that of man: nor is it to be wondered at, that, seeing her perfect and exquisite creations poured forth in a profusion which conception could not grasp nor calculation sum, he should think that it ill became him to be niggardly of his own rude craftsmanship; and where he saw throughout the universe a faultless beauty lavished on measureless spaces of broidered field and blooming mountain, to grudge his poor & imperfect labour to the few stones that he had raised one upon another, for habitation or memorial. The years of his life passed away before his task was accomplished; but generation succeeded generation with unwearied enthusiasm, and the cathedral front was at last lost in the tapestry of its traceries, like a rock among the thickets and herbage of spring.

E have now, I believe, obtained a view ap⟋ proaching to comple⟋ teness of the various moral or imaginative elements which com⟋ posed the inner spirit of Gothic architect⟋ ure. We have, in the second place, to define its outward form. ℂ Now, as the Gothic spirit is made up of several elements, some of which may, in particular examples, be wanting, so the Gothic form is made up of minor conditions of form, some of which may, in particular examples, be imper⟋ fectly developed. We cannot say, therefore, that a building is either Gothic or not Gothic in form, any more that we can in spirit. We can only say that it is more or less Gothic, in proportion to the number of Gothic forms which it unites.

HERE have been made lately many subtle and ingenious endea⟋ vours to base the definition of Go⟋ thic form entirely upon the roof⟋ vaulting; endeavours which are both forced and futile: for many of the best Gothic buildings in the world have roofs of timber, which have no more connexion with the main structure of the walls of the edifice than a hat has with that of the head it protects; and other

89

Gothic buildings are merely enclosures of spaces, as ramparts and walls, or enclosures of gardens or cloisters, and have no roofs at all, in the sense in which the word "roof" is commonly accepted. But every reader who has ever taken the slightest interest in architecture must know that there is a great popular impression on this matter, which maintains itself stiffly in its old form, in spite of all ratiocination and definition; namely, that a flat lintel from pillar to pillar is Grecian, a round arch Norman or Romanesque, and a pointed arch Gothic. And the old popular notion, as far as it goes, is perfectly right, and can never be bettered. The most striking outward feature in all Gothic architecture is, that it is composed of pointed arches, as in Romanesque that it is in like manner composed of round; & this distinction would be quite as clear, though the roofs were taken off every cathedral in Europe. ⁌ And yet if we examine carefully into the real force and meaning of the term "roof," we shall perhaps be able to retain the old popular idea in a definition of Gothic architecture which shall also express whatever dependence that architecture has upon true forms of roofing.

N Chap. XIII. of the first volume of The Stones of Venice, the reader will remember that roofs were considered as generally divided into two parts: the roof proper, that is to say, the shell, vault, or ceiling,

90

internally visible; and the roof mask, which pro The Nature
tects this lower roof from the weather. In some of Gothic
buildings these parts are united in one framework;
but, in most, they are more or less independent of
each other, & in nearly all Gothic buildings there
is a considerable interval between them. ¶ Now
it will often happen, as above noticed, that owing
to the nature of the apartments required, or the
materials at hand, the roof proper may be flat,
coved or domed, in buildings which in their walls
employ pointed arches, and are, in the straitest
sense of the word, Gothic in all other respects. Yet
so far forth as the roofing alone is concerned, they
are not Gothic unless the pointed arch be the prin-
cipal form adopted either in the stone vaulting or
the timbers of the roof proper. ¶ I shall say then,
in the first place, that "Gothic architecture is that
which uses, if possible, the pointed arch in the roof
proper." This is the first step in our definition.

ECONDLY, Although there
may be many advisable or neces-
sary forms for the lower roof or
ceiling, there is, in cold countries
exposed to rain & snow, only one
advisable form for the roof-mask,
and that is the gable, for this alone will throw off
both rain and snow from all parts of its surface as
speedily as possible. Snow can lodge on the top of
a dome, not on the ridge of a gable. And thus, as
far as roofing is concerned, the gable is a far more

91

The Nature
of Gothic

See Appendix
Note M.

essential feature of Northern architecture than
the pointed vault, for the one is a thorough neces-
sity, the other often a graceful conventionality;
the gable occurs in the timber roof of every dwel-
ling-house and every cottage, but not the vault;
& the gable built on a polygonal or circular plan,
is the origin of the turret and spire; and all the
so-called aspiration of Gothic architecture is, as
noticed (Vol. I. Chap. XII. Sec. vi. of The Stones
of Venice), nothing more than its development.
So that we must add to our definition another
clause, which will be, at present, by far the most
important, and it will stand thus: "Gothic archi-
tecture is that which uses the pointed arch for the
roof proper, and the gable for the roof-mask."

AND here, in passing, let us notice
a principle as true in architecture
as in morals. It is not the com-
pelled, but the wilful, transgression
of law which corrupts the charac-
ter. Sin is not in the act, but in the
choice. It is a law for Gothic architecture, that it
shall use the pointed arch for its roof proper; but
because, in many cases of domestic building, this
becomes impossible for want of room (the whole
height of the apartment being required every-
where), or in various other ways inconvenient, flat
ceilings may be used, and yet the Gothic shall not
lose its purity. ¶But in the roof-mask, there can
be no necessity nor reason for a change of form:

the gable is the best; and if any other, dome, or bulging crown, or whatsoever else, be employed at all, it must be in pure caprice and wilful trans/ gression of law. And wherever, therefore, this is done, the Gothic has lost its character; it is pure Gothic no more.

A N D this last clause of the defini/ tion is to be more strongly insisted upon, because it includes multitu/ des of buildings, especially domes/ tic, which are Gothic in spirit, but which we are not in the habit of embracing in our general conception of Gothic ar/ chitecture; multitudes of street dwelling/houses and straggling country farm/houses, built with little care for beauty, or observance of Gothic laws in vaults or windows, and yet maintaining their character by the sharp and quaint gables of the roofs. And, for the reason just given, a house is far more Gothic which has square windows, and a boldly gable roof, than one which has pointed arches for the windows, and a domed or flat roof. For it often happened in the best Gothic times, as it must in all times, that it was more easy and convenient to make a window square than point/ ed: not but that, as above emphatically stated, the richness of church architecture was also found in domestic; and systematically "when the point/ ed arch was used in the church it was used in the street," only in all times there were cases in which men could not build as they would, and were ob/

93

liged to construct their doors or windows in the readiest way; and this readiest way was then, in small work, as it will be to the end of time, to put

Fig. VIII.

a flat stone for a lintel, & build the windows as in Fig. VIII.; & the occur‑rence of such windows in a building or a street will not un‑Gothicize them, so long as the bold gable roof be retained, and the spirit of the work be visibly Gothic in other re‑spects. But if the roof be wilfully and conspicu‑ously of any other form than the gable, if it be domed, or Turkish, or Chinese, the building has positive corruption, mingled with its Gothic ele‑ments, in proportion to the conspicuousness of the roof; and, if not absolutely un‑Gothicized, can maintain its character only by such vigour of vital Gothic energy in other parts as shall cause the roof to be forgotten, thrown off like an eschar from the living frame. Nevertheless, we must al‑ways admit that it may be forgotten, and that if the Gothic seal be indeed set firmly on the walls, we are not to cavil at the forms reserved for the tiles and leads. For, observe, as our definition at present stands, being understood of large roofs only, it will allow a conical glass‑furnace to be a Gothic building; but will not allow so much, ei‑ther of the Duomo of Florence, or the Baptistery of Pisa. We must either mend it, therefore, or un‑derstand it in some broader sense.

AND now, if the reader will look back to the fifth paragraph of Chap. III., Vol. I. of The Stones of Venice, he will find that I carefully extended my definition of a roof so as to include more than is usually understood by the term. It was there said to be the covering of a space, narrow or wide. It does not in the least signify, with respect to the real nature of the covering, whether the space protected be two feet wide, or ten; though in the one case we call the protection an arch, in the other a vault or roof. But the real point to be considered is, the manner in which this protection stands, and not whether it is narrow or broad. We call the vaulting of a bridge "an arch," because it is narrow with respect to the river it crosses; but if it were built above us on the ground, we should call it a waggon vault, because then we should feel the breadth of it. The real question is the nature of the curve, not the extent of space over which it is carried: and this is more the case with respect to Gothic than to any other architecture; for in the greater number of instances, the form of the roof is entirely dependent on the ribs; the domical shells being constructed in all kinds of inclinations, quite indeterminable by the eye, and all that is definite in their character being fixed by the curves of the ribs.

ET us then consider our definition as including the narrowest arch, or tracery bar, as well as the broadest roof, and it will be nearly a perfect one. For the fact is, that all good Gothic is nothing more than the development, in various ways, and on every conceivable scale, of the group formed by the pointed arch for the bearing line below, and the gable for the protecting line above; & from the huge, grey, shaly slope of the cathedral roof, with its elastic pointed vaults beneath, to the slight crown-like points that enrich the smallest niche of its doorway, one law & one expression will be found in all. The modes of support and of decoration are infinitely various, but the real character of the building, in all good Gothic, depends upon the single lines of the gable over the pointed arch, Fig: IX, endlessly rearranged or repeated. The larger woodcut, Fig: X. on pages 97 & 98, represents three characteristic conditions of the treatment of the group: a, from a tomb at Verona (1328); b, one of the lateral porches at Abbeville; c, one of the uppermost points of the great western facade of Rouen Cathedral; both these last being, I believe, early work of the fifteenth century. The forms of the pure early English & French Gothic are too well known to need any notice: my reason will appear presently for choosing, by way of example, these somewhat rare conditions.

Fig: IX

96

UT, first, let us try whether we can not get the forms of the other great architectures of the world broadly expressed by relations of the same lines into which we have compres/sed the Gothic. We may easily do this if the reader will first allow me to remind him of the true nature of the pointed arch, as it was ex/pressed in Sec. x. Chap. X. of the first volume of The Stones of Venice. It was said there, that it ought to be called a "curved gable," for, strictly speaking, an "arch" cannot be "pointed." The so/called pointed arch ought always to be considered as a gable, with its sides curved in order to en/able them to bear pressure from without. Thus considering it, there are but three ways in which an interval between piers can be bridged, the three ways represented by a, b, and c, Fig: XI., on page 98, a, the lintel; b, the round arch; c, the gable. All the architects in the world will never discover any other ways of bridging a space than these three; they may vary the curve of the arch, or curve the sides of the gable or break them; but in doing this they are mere/ly modifying or subdivid/

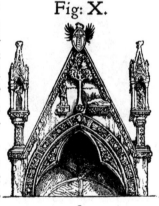

Fig: X.

a

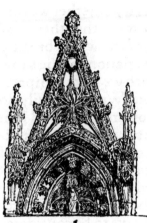

b

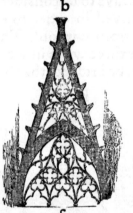

c

Fig: XI.

ing, not adding to the generic forms. ❡ Now there are three good architectures in the world, and there never can be more, correspondent to each of these three simple ways of covering in a space, which is the original function of all architectures. And those three architectures are pure exactly in proportion to the simplicity and directness with which they express the condition of roofing on which they are founded. They have many interesting varieties, according to their scale, manner of decoration, and character of the nations by whom they are practised, but all their varieties are finally referable to the three great heads:

a, Greek: Architecture of the Lintel. b, Romanesque: Architecture of the Round Arch. c, Gothic: Architecture of the Gable.

a b c

98

¶ The three names, Greek, Romanesque, and Gothic, are indeed inaccurate when used in this vast sense, because they imply national limita, tions; but the three architectures may neverthe, less not unfitly receive their names from those nations by whom they were carried to the highest perfection. We may thus briefly state their ex, isting varieties.

a, GREEK: Lintel Architecture:

HE worst of the three; and, consi, dered with reference to stone con, struction, always in some meas, ure barbarous. Its simplest type is Stonehenge; its most refined, the Parthenon; its noblest, the Tem, ple of Karnak. ¶ In the hands of the Egyptian, it is sublime; in those of the Greek, pure; in those of the Roman, rich; and in those of the Renais, sance builder, effeminate.

b, ROMANESQUE: Round, arch Architec, ture:

EVER thoroughly developed un, til Christian times. It falls into two great branches, Eastern & West, ern, or Byzantine and Lombardic; changing respectively in process of time, with certain helps from each other, into Arabian Gothic, and Teutonic Gothic. Its most perfect Lombardic type is the Duomo of Pisa; its most perfect Byzantine type (I believe),

St. Mark's at Venice. Its highest glory is, that it
has no corruption. It perishes in giving birth to
another architecture as noble as itself.

c, GOTHIC: Architecture of the Gable:

THE daughter of the Romanesque;
and, like the Romanesque, divid-
ed into two great branches, West-
ern and Eastern, or Pure Gothic &
Arabian Gothic; of which the lat-
ter is called Gothic, only because it
has many Gothic forms, pointed arches, vaults,
etc., but its spirit remains Byzantine, more es-
pecially in the form of the roof-mask, of which,
with respect to these three great families, we have
next to determine the typical form.

FOR, observe, the distinctions we
have hitherto been stating depend
on the form of the stones first laid
from pier to pier; that is to say, of
the simplest condition of roofs pro-
per. Adding the relations of the
roof-mask to these lines, we shall have the per-
fect type of form for each school. ⁋ In the Greek,
the Western Romanesque, and Western Gothic,
the roof-mask is the gable; in the Eastern Ro-
manesque, and Eastern Gothic, it is the dome:
but I have not studied the roofing of either of these
last two groups, and shall not venture to genera-
lise them in a diagram. But the three groups, in the
hands of the Western builders, may be thus simply

represented: a, Fig:
XII., Greek; b, West-
ern Romanesque; c,
Western, or true, Go-
thic. ❡Now, observe,
first, that the relation
of the roof-mask to
the roof proper, in the Greek type, forms that pe-
diment which gives its most striking character to
the temple, and is the principal recipient of its
sculptural decoration. The relation of these lines,
therefore, is just as important in the Greek as in
the Gothic schools.

Fig: XII.

a b c

See Appendix
Note N.

SECONDLY, the reader must ob-
serve the difference of steepness in
the Romanesque and Gothic ga-
bles. This is not an unimportant
distinction, nor an undecided one.
The Romanesque gable does not
pass gradually into the more elevated form; there
is a great gulf between the two; the whole effect
of all Southern architecture being dependent up-
on the use of the flat gable, and of all Northern
upon that of the acute. I need not here dwell up-
on the difference between the lines of an Italian
village, or the flat tops of most Italian towers, and
the peaked gables and spires of the North, attain-
ing their most fantastic development, I believe,
in Belgium: but it may be well to state the law of
separation, namely, that a Gothic gable must have

all its angles acute, and a Romanesque one must have the upper one obtuse; or, to give the reader a simple practical rule, take any gable, a or b, Fig: XIII., and strike a semicircle on its base; if its top rises above the semicircle, as at b, it is a Gothic gable; if it falls beneath it, a Roman﹣esque one; but the best forms in each group are those which are dis﹣tinctly steep, or distinctly low. In the figure, f is, perhaps, the average of Romanesque slope, and g of Gothic.

Fig: XIII.

a b

f g

BUT although we do not find a tran﹣sition from one school into the other in the slope of the gable, there is often a confusion between the two schools in the association of the ga﹣ble with the arch below it. It has just been stated that the pure Romanesque con﹣dition is the round arch under the low gable, a, Fig: XIV. on next page, and the pure Gothic con﹣dition is the pointed arch under the high gable, b. But in the passage from one style to the other, we sometimes find the two conditions reversed; the pointed arch under a low gable, as d, or the round arch under a high gable, as c. The form d occurs in the tombs of Verona, and c in the doors of Venice.

Fig: XIV.

a b c d

E have thus determined the relation of Gothic to the other architectures of the world, as far as regards the main lines of its construction; but there is still one word which needs to be added to our definition of its form, with respect to a part of its decoration, which rises out of that construction. We

have seen that the first condition of its form, is, that it shall have pointed arches. When Gothic is perfect, therefore, it will follow that the pointed arches must be built in the strongest possible manner. ❡ Now, if the reader will look to Chap. XI. Vol. I., of the Stones of Venice, he will find the subject of the ma

Fig: XV.

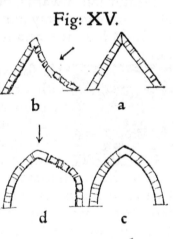

b a

d c

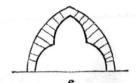

e

sonry of the pointed arch discussed at length, and the conclusion deduced, that of all possible forms of the pointed arch (a certain weight of material being given), that generically represented at e, Fig: XV., is the strongest. In fact, the reader can see in a moment that the weakness of the pointed arch is in its flanks, and that by merely thickening them gradually at this point all chance of fracture is removed. Or, perhaps, more simply still: Suppose a gable built of stone, as at a, and pressed upon from without by a weight in the direction of the arrow, clearly it would be liable to fall in, as at b. To prevent this, we make a pointed arch of it, as at c; & now it cannot fall inwards, but if pressed upon from above may give way outwards, as at d. But at last we build it as at e, and now it can neither fall out nor in.

THE forms of arch thus obtained, with a pointed projection called a cusp on each side, must for ever be delightful to the human mind, as being expressive of the utmost strength and permanency obtainable with a given mass of material. But it was not by any such process of reasoning, nor with any reference to laws of construction, that the cusp was originally invented. It is merely the special appli-

104

cation to the arch of the great ornamental system of FOLIATION; or the adaptation of the forms of leafage which has been above insisted upon as the principal characteristic of Gothic Naturalism. This love of foliage was exactly proportioned, in its intensity, to the increase of strength in the Gothic spirit: in the Southern Gothic it is soft leafage that is most loved; in the Northern, thorny leafage. And if we take up any northern illuminated manuscript of the great Gothic time, we shall find every one of its leaf ornaments surrounded by a thorny structure laid round it in gold or in colour; sometimes apparently copied faithfully from the prickly development of the **Fig. XVI.** root of the leaf in the thistle, running along the stems and branches exactly as the thistle leaf does along its own stem, and with sharp spines proceeding from the points, as in Fig. XVI. At other times, & for the most part in work of the thirteenth century, the golden ground takes the form of pure and severe cusps, sometimes enclosing the leaves, sometimes filling up the forks of the branches (as in the example fig. 1, Plate I., Vol. III. of The Stones of Venice), passing imperceptibly from the distinctly vegetable condition (in which it is just as cer-

tainly representative of the thorn, as other parts
of the design are of the bud, leaf, & fruit) into the crests on the necks, or the membranous sails of the wings, of serpents, dra, ons, & other grotesques, as in Fig. XVII. and into rich & vague fantasies of curvature; among which, however, the pure cusped system of the pointed arch is continually discernible, not accidentally, but designedly indicated, and connecting itself with the literally architectural portions of the design.

Fig. XVII.

THE system, then, of what is called Foliation, whether simple, as in the cusped arch, or complicated, as in tracery, rose out of this love of leafage; not that the form of the arch is intended to imitate a leaf, but to be invested with the same characters of beauty which the designer had discovered in the leaf. Observe, there is a wide difference between these two intentions. The idea that large Gothic structure, in arches and roofs, was intended to imitate vegetation, is, as above noticed, unten, able for an instant in the front of facts. But the Gothic builder perceived that, in the leaves which he copied for his minor decorations, there was a

peculiar beauty, arising from certain characters of curvature in outline, and certain methods of subdivision and of radiation in structure. On a small scale, in his sculptures & his missal-paint-ing, he copied the leaf or thorn itself; on a large scale he adopted from it its abstract sources of beauty, and gave the same kind of curvatures and the same species of subdivision to the outline of his arches, so far as was consistent with their strength, never, in any single instance, suggest-ing the resemblance to leafage by irregularity of outline, but keeping the structure perfectly sim-ple, and, as we have seen, so consistent with the best principles of masonry, that in the finest Go-thic designs of arches, which are always single-cusped (the cinquefoiled arch being licentious, though in early work often very lovely), it is liter-ally impossible, without consulting the context of the building, to say whether the cusps have been added for the sake of beauty or of strength; nor, though in mediæval architecture they were, I believe, assuredly first employed in mere love of their picturesque form, am I absolutely certain that their earliest invention was not a structural effort. For the earliest cusps with which I am ac-quainted are those used in the vaults of the great galleries of the Serapeum, discovered in 1850 by M. Mariette at Memphis, and described by Col-onel Hamilton in a paper read February 23, 1853, before the Royal Society of Literature. The roofs

of its galleries were admirably shown in Colonel Hamilton's drawings made to scale upon the spot, and their profile is a cusped round arch, per- fectly pure and simple; but whether thrown into this form for the sake of strength or of grace, I am unable to say.

T is evident, however, that the structural advantage of the cusp is available only in the case of arches on a comparatively small scale. If the arch becomes very large, the projections under the flanks must become too ponderous to be secure; the suspend- ed weight of stone would be liable to break off, and such arches are therefore never constructed with heavy cusps, but rendered secure by general mass of masonry; & what additional appearance of support may be thought necessary (sometimes a considerable degree of actual support) is given by means of tracery.

F what I stated in the second chap- ter of the Seven Lamps, respecting the nature of tracery, I need repeat here only this much, that it began in the use of penetrations through the stonework of windows or walls, cut into forms which looked like stars when seen from within, & like leaves when seen from with- out; the name foil or feuille being universally ap- plied to the separate lobes of their extremities,

and the pleasure re-
ceived from them
being the same as
that which we feel
in the triple, quad-
ruple or other radi-
ated leaves of vege-
tation, joined with
the perception of a
severely geometrical
order & symmetry.
A few of the most
common forms are
represented uncon-
fused by exterior
mouldings, in Fig.
XVIII., & the best
traceries are nothing
more than clusters of such forms, with mouldings
following their outlines.

Fig. XVIII.

THE term "foliated," therefore, is
equally descriptive of the most per-
fect conditions both of the simple
arch and of the traceries by which
in later Gothic it is filled; and this
foliation is an essential character
of the style. No Gothic is either good or charac-
teristic, which is not foliated either in its arches or
apertures. Sometimes the bearing arches are fo-
liated, and the ornamentation above composed of

109

figure sculpture; sometimes the bearing arches are plain, and the ornamentation above them is composed of foliated apertures. But the element of foliation must enter somewhere, or the style is imperfect. And our final definition of Gothic will therefore, stand thus: "FOLIATED Architecture, which uses the pointed arch for the roof proper, and the gable for the roof-mask."

AND now there is but one point more to be examined, & we have done. ℭ Foliation, while it is the most distinctive and peculiar, is also the easiest method of decoration which Gothic architecture possesses; and, although in the disposition of the proportions and forms of foils, the most noble imagination may be shown, yet a builder without imagination at all, or any other faculty of design, can produce effect upon the mass of his work by merely covering it with foolish foliation. Throw any number of crossing lines together at random, as in Figure XIX., and fill all their squares

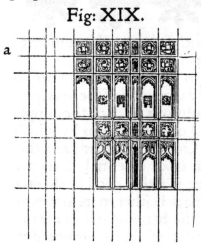

Fig: XIX.

a

and oblong openings with quatrefoils & cinque\, \,\,
foils, and you will immediately have what will
stand, with most people, for very satisfactory
Gothic. The slightest possible acquaintance with
existing forms will enable any architect to vary
his patterns of foliation with as much ease as he
would those of a kaleidoscope, and to produce a
building which the present European public will
think magnificent, though there may not be, from
foundation to coping, one ray of invention, or any
other intellectual merit, in the whole mass of it.
But floral decoration, & the disposition of mould‚
ings, require some skill & thought; and, if they are
to be agreeable at all, must be verily invented, or ac‚
curately copied. They cannot be drawn altogether
at random, without becoming so commonplace as
to involve detection: and although, as I have just
said, the noblest imagination may be shown in
the disposition of traceries, there is far more room
for its play and power when those traceries are as‚
sociated with floral or animal ornament; and it is
probable, a priori, that, wherever true invention
exists, such ornament will be employed in pro‚
fusion.

OW, all Gothic may be divided in‚
to two vast schools, one early, the
other late; of which the former, no‚ See Appendix Note O.
ble, inventive, & progressive, uses
the element of foliation moderate‚
ly, that of floral & figure sculpture

decoration profusely; the latter, ignoble, uninven-
tive, and declining, uses foliation immoderately,
floral & figure sculpture subordinately. The two
schools touch each other at that instant of mo-
mentous change, dwelt upon in the Seven Lamps,
Chap. II., p. 54, a period later or earlier in differ-
ent districts, but which may be broadly stated as
the middle of the fourteenth century; both styles
being, of course, in their highest excellence at the
moment when they meet; the one ascending to
the point of junction, the other declining from it,
but, at first, not in any marked degree, and only
showing the characters which justify its being
above called, generically, ignoble, as its declen-
sion reaches steeper slope.

F these two great schools, the first
uses foliation only in large & sim-
ple masses, and covers the minor
members, cusps, etc., of that folia-
tion with various sculpture. The
latter decorates foliation itself with
minor foliation, & breaks its traceries into endless
and lace-like subdivision of tracery. ❡ A few in-
stances will explain the difference clearly. Fig: 2,
Plate XII. represents half of an eight-foiled aper-
ture from Salisbury; where the element of folia-
tion is employed in the larger disposition of the
starry form; but in the decoration of the cusp it has
entirely disappeared, and the ornament is floral.
❡ But in Fig: 1, which is part of a fringe round one

112

of the later windows in Rouen Cathedral, the folia-
tion is first carried boldly round the arch, and then
each cusp of it divided into other forms of foliation.
The two larger canopies of niches below, Figs: 5
and 6, are respectively those seen at the flanks of
the two uppermost examples of gabled Gothic in
Fix: X., pages 97 and 98. Those examples were
there chosen in order also to illustrate the distinc-
tion in the character of ornamentation which we
are at present examining; & if the reader will look
back to them, and compare their methods of treat-
ment, he will at once be enabled to fix that distinc-
tion clearly in his mind. He will observe that in
the uppermost the element of foliation is scrupu-
lously confined to the bearing arches of the gable,
and of the lateral niches, so that, on any given side
of the monument, only three foliated arches are
discernible. All the rest of the ornamentation is
"bossy sculpture," set on the broad marble sur-
face. On the point of the gable are set the shield
and dog-crest of the Scalas, with its bronze wings,
as of a dragon, thrown out from it on either side;
below, an admirably sculptured oak-tree fills the
centre of the field; beneath it is the death of Abel,
Abel lying dead upon his face on one side, Cain
opposite, looking up to heaven in terror: the bor-
der of the arch is formed of various leafage, alter-
nating with the Scala shield; & the cusps are each
filled by one flower, and two broad flowing leaves.
The whole is exquisitely relieved by colour; the

i i

ground being of pale red Verona marble, and the
statues & foliage of white Carrara marble, inlaid.
THE figure below it, b, represents
the southern lateral door of the
principal church in Abbeville; the
smallness of the scale compelled
me to make it somewhat heavier in
the lines of its traceries than it is in
reality, but the door itself is one of the most ex-
quisite pieces of flamboyant Gothic in the world;
and it is interesting to see the shield introduced
here, at the point of the gable, in exactly the same
manner as in the upper example, and with pre-
cisely the same purpose, to stay the eye in its as-
cent, & to keep it from being offended by the sharp
point of the gable, the reversed angle of the shield
being so energetic as completely to balance the
upward tendency of the great convergent lines. It
will be seen, however, as this example is studied,
that its other decorations are altogether different
from those of the Veronese tomb; that, here, the
whole effect is dependent on mere multiplications
of similar lines of tracery, sculpture being hardly
introduced except in the seated statue under the
central niche, and, formerly, in groups filling the
shadowy hollows under the small niches in the
archivolt, but broken away in the Revolution. And
if now we turn to Plate XII., just passed, and ex-
amine the heads of the two lateral niches there
given from each of these monuments on a larger

scale, the contrast will be yet more apparent. The one from Abbeville (Fig: 5), though it contains much floral work of the crisp Northern kind in its finial and crockets, yet depends for all its effect on the various patterns of foliation with which its spaces are filled; and it is so cut through & through that it is hardly stronger than a piece of lace: whereas the pinnacle from Verona depends for its effect on one broad mass of shadow, boldly shaped into the trefoil in its bearing arch; and there is no other trefoil on that side of the niche. All the rest of its decoration is floral, or by almonds & bosses; and its surface of stone is unpierced, and kept in broad light, and the mass of it thick and strong enough to stand for as many more centuries as it has already stood, scatheless, in the open street of Verona. The figures 3 and 4, above each niche, show how the same principles are carried out into the smallest details of the two edifices, 3 being the moulding which borders the gable at Abbeville, and 4 that in the same position at Verona; and as thus in all cases the distinction in their treatment remains the same, the one attracting the eye to broad sculptured surfaces, the other to involutions of intricate lines, I shall hereafter characterize the two schools, whenever I have occasion to refer to them, the one as Surface Gothic, the other as Linear Gothic.

OW observe: it is not, at present, the question, whether the form of the Veronese niche, & the design of its flower-work, be as good as they might have been; but simply, which of the two architectural principles is the greater and better. And this we cannot hesitate for an instant in deciding. The Veronese Gothic is strong in its masonry, simple in its masses, but perpetual in its variety. The late French Gothic is weak in masonry, broken in mass, & repeats the same idea continually. It is very beautiful, but the Italian Gothic is the nobler style.

ET, in saying that the French Gothic repeats one idea, I mean merely that it depends too much upon the foliation of its traceries. The disposition of the traceries themselves is endlessly varied and inventive; and, indeed, the mind of the French workman was, perhaps, even richer in fancy than that of the Italian, only he had been taught a less noble style. This is especially to be remembered with respect to the subordination of figure sculpture above noticed as characteristic of the later Gothic. ⁋ It is not that such sculpture is wanting; on the contrary, it is often worked into richer groups, and carried out with a perfection of execution, far greater than those which adorn the earlier buildings: but, in the early work, it is vigorous, pro-

minent, and essential to the beauty of the whole; in the late work, it is enfeebled, and shrouded in the veil of tracery, from which it may often be re/ moved with little harm to the general effect.

OW the reader may rest assured that no principle of art is more ab/ solute than this, that a composi/ tion from which anything can be removed without doing mischief, is always so far forth inferior. On this ground, therefore, if on no other, there can be no question, for a moment, which of the two schools is the greater; although there are many most noble works in the French traceried Gothic, having a sublimity of their own, dependent on their extreme richness and grace of line, and for which we may be most grateful to their builders. And, indeed, the superiority of the Surface Goth/ ic cannot be completely felt, until we compare it with the more degraded Linear schools, as, for in/ stance, with our own English perpendicular. The ornaments of the Veronese niche, which we have used for our example, are by no means among the best of their school, yet they will serve our pur/ pose for such a comparison. That of its pinnacle is composed of a single upright flowering plant, of which the stem shoots up through the centres of the leaves, and bears a pendent blossom, some/ what like that of the imperial lily. The leaves are thrown back from the stem with singular grace

The Nature of Gothic

See Appendix Note P.

Fig: **XX.**

and freedom, and foreshortened, as if by a skilful painter, in the shallow marble relief. Their arrangement is roughly shown in the little woodcut at the side (Fig: **XX.**); & if the reader will simply try the experiment for himself, first, of covering a piece of paper with crossed lines, as if for accounts, and filling all the interstices with any foliation that comes into his head, as in Fig: **XIX.** above; and then of trying to fill the point of a gable with a piece of leafage like that in Fig: **XX.**, putting the figure itself aside, he will presently find that more thought and invention are required to design this single minute pinnacle, than to cover acres of ground with English perpendicular.

E have now, I believe, obtained a sufficiently accurate knowledge both of the spirit and form of Gothic architecture; but it may, perhaps, be useful to the general reader, if, in conclusion, I set down a few plain and practical rules for determining, in every instance, whether a given building be good Gothic or not, and, if not Gothic, whether its architecture is of a kind which will probably reward the pains of careful examination.

FIRST, Look if the roof rises in a steep gable, The Nature
high above the walls. If it does not do this, there of Gothic
is something wrong: the building is not quite
pure Gothic, or has been altered.
SECONDLY, Look if the principal windows
and doors have pointed arches with gables over
them. If not pointed arches, the building is not
Gothic; if they have not any gables over them, it
is either not pure, or not first-rate. ⁋ If, however,
it has the steep roof, the pointed arch, and gable
all united, it is nearly certain to be a Gothic build-
ing of a very fine time.
THIRDLY, Look if the arches are cusped, or
apertures foliated. If the building has met the
first two conditions, it is sure to be foliated some-
where; but, if not everywhere, the parts which
are unfoliated are imperfect, unless they are large
bearing arches, or small & sharp arches in groups,
forming a kind of foliation by their own multipli-
city, & relieved by sculpture and rich mouldings.
The upper windows, for instance, in the east end
of Westminster Abbey are imperfect for want of
foliation. If there be no foliation anywhere, the
building is assuredly imperfect Gothic.
FOURTHLY, If the building meets all the
first three conditions, look if its arches in general,
whether of windows and doors, or of minor orna-
mentation, are carried on true shafts with bases
and capitals. If they are, then, the building is as-
suredly of the finest Gothic style. It may still,

perhaps, be an imitation. a feeble copy, or a bad example, of a noble style; but the manner of it, having met all these four conditions, is assuredly first-rate. ⁋ If its apertures have not shafts and capitals, look if they are plain openings in the walls, studiously simple, and unmoulded at the sides; as, for instance, the arch in Plate XIX., p. 323, Vol. I. of the Stones of Venice. If so, the building may still be of the finest Gothic adapted to some domestic or military service. But if the sides of the window be moulded, and yet there are no capitals at the spring of the arch, it is as-suredly of an inferior school. ⁋ This is all that is necessary to determine whether the building be of a fine Gothic style. The next tests to be ap-plied are in order to discover whether it be good architecture or not; for it may be very impure Gothic, and yet very noble architecture; or it may be very pure Gothic, & yet if a copy, or originally raised by an ungifted builder, very bad architec-ture. ⁋ If it belong to any of the great schools of colour, its criticism becomes as complicated, and needs as much care, as that of a piece of music, & no general rules for it can be given; but if not:

IRST, See if it looks as if it had been built by strong men; if it has the sort of roughness, and large-ness, and nonchalance, mixed in places with the exquisite tender-ness which seems always to be the

sign-manual of the broad vision, & massy power of men who can see past the work they are doing, and betray here and there something like disdain for it. If the building has this character, it is much already in its favour; it will go hard but it proves a noble one. If it has not this, but is altogether accurate, minute, and scrupulous in its workman-ship, it must belong to either the very best or the very worst of schools: the very best, in which ex-quisite design is wrought out with untiring and conscientious care, as in the Giottesque Gothic; or the very worst, in which mechanism has taken the place of design. It is more likely, in general, that it should belong to the worst than the best: so that, on the whole, very accurate workmanship is to be esteemed a bad sign; and if there is noth-ing remarkable about the building but its preci-sion, it may be passed at once with contempt.

ECONDLY, Observe if it be irregular, its different parts fitting themselves to different purposes, no one caring what becomes of them, so that they do their work. If one part always answers accur-ately to another part, it is sure to be a bad build-ing; and the greater and more conspicuous the ir-regularities, the greater the chances are that it is a good one. For instance, in the Ducal Palace, of which a rough woodcut is given in Chap. VIII. of the Stones of Venice, the general idea is sternly

121

symmetrical; but two windows are lower than the rest of the six; and if the reader will count the arches of the small arcade as far as to the great balcony, he will find it is not in the centre, but set to the right-hand side by the whole width of one of those arches. We may be pretty sure that the building is a good one; none but a master of his craft would have ventured to do this.

THIRDLY, Observe if all the traceries, capitals, & other ornaments are of perpetually varied design. If not, the work is assuredly bad.

LASTLY, Read the sculpture. Preparatory to reading it, you will have to discover whether it is legible (and, if legible, it is nearly certain to be worth reading). On a good building, the sculpture is always so set, and on such a scale, that at the ordinary distance from which the edifice is seen, the sculpture shall be thoroughly intelligible and interesting. In order to accomplish this, the uppermost statues will be ten or twelve feet high, and the upper ornamentation will be colossal, increasing in fineness as it descends, till on the foundation it will often be wrought as if for a precious cabinet in a king's chamber; but the spectator will not notice that the upper sculptures are co-

lossal. He will merely feel that he can see them The Nature plainly, and make them all out at his ease. ¶ And of Gothic having ascertained this, let him set himself to read them. Thenceforward the criticism of the build, ing is to be conducted precisely on the same prin, ciples as that of a book; and it must depend on the knowledge, feeling, and not a little on the in, dustry and perseverance of the reader, whether. even in the case of the best works, he either per, ceive them to be great, or feel them to be enter, taining.

APPENDIX.

Note A, page 32. The Elgin marbles are supposed by many persons to be "perfect." In the most important portions they indeed approach perfection, but only there. The draperies are unfinished, the hair and wool of the animals are unfinished, and the entire bas-reliefs of the frieze are roughly cut. Note B, page 45. In the eighth chapter of The Stones of Venice is noticed a remarkable instance of this sacrifice of symmetry to convenience in the arrangement of the windows of the Ducal Palace. Note C, page 49. I am always afraid to use this word "Composition;" it is so utterly misused in the general parlance respecting art. Nothing is more common than to hear divisions of art into "form, composition, and colour," or "light and shade & composition," or "sentiment & composition," or it matters not what else and composition; the speakers in each case attaching a perfectly different meaning to the word, generally an indistinct one, and always a wrong one. Composition is in, plain English, "putting together," and it means the putting together of lines, of forms, of colours, of shades, or of ideas. Painters compose in colour, compose in thought, compose in form, and compose in effect; the word being of use merely in order to express a scientific, disciplined, & inventive arrangement of any of these, instead of a merely natural or accidental one.

124

Note D, page 51. Design is used in this place as expressive of the power to arrange lines & colours nobly. By facts, I mean facts perceived by the eye and mind, not facts accumulated by knowledge. See the chapter in The Stones of Venice on Roman Renaissance (Vol. III. Chap. II.) for this distinction.

Note E, page 52. The plates here spoken of could not be given, but it was impossible not to give the text which refers to them. W.M.

Note F, page 54. "Earlier," that is to say, pre-Raphaelite ages. Men of this stamp will praise Claude, and such other comparatively debased artists; but they cannot taste the work of the thirteenth century.

Note G, page 63. Not selfish fear, caused by want of trust in God, or of resolution in the soul. Compare "Modern Painters," vol. ii., p. 120.

Note H, page 69. I reserve for another place the full discussion of this interesting subject, which here would have led me too far; but it must be noted, in passing, that this vulgar Purism, which rejects truth, not because it is vicious, but because it is humble, and consists not in choosing what is good, but in disguising what is rough, extends itself into every species of art. The most definite instance of it is the dressing of characters of peasantry in an opera or ballet scene; and the walls of our exhibitions are full of works of art which "exalt nature" in the same way, not by revealing

Appendix what is great in the heart, but by smoothing what is coarse in the complexion. There is nothing, I believe, so vulgar, so hopeless, so indicative of an irretrievably base mind, as this species of Purism. Of healthy Purism carried to the utmost endurable length in this direction, exalting the heart first, and the features with it, perhaps the most characteristic instance I can give is Stothard's vignette to "Jorasse," in Roger's Italy; at least it would be so if it could be seen beside a real group of Swiss girls. The poems of Rogers, compared with those of Crabbe, are admirable instances of of the healthiest Purism and healthiest Naturalism in poetry. The first great Naturalists of Christian art were Orcagna and Giotto.

Note I, page 75. The best art either represents the facts of its own day, or, if facts of the past, expresses them with accessaries of the time in which the work was done. All good art, representing past events, is therefore full of the most frank anachronism, and always OUGHT to be. No painter has any business to be an antiquarian. We do not want his impressions or suppositions respecting things that are past. We want his clear assertions respecting things present.

Note K, page 85. See the account of the meeting at Talla Linns, in 1682, given in the fourth chapter of the "Heart of Midlothian." At length they arrived at the conclusion that "they who owned (or allowed) such names as Monday, Tuesday,

January, February, & so forth, served themselves
heirs to the same if not greater punishment than
had been denounced against the idolaters of old."
Note L, page 86. See the beautiful description of
Florence in Elizabeth Browning's "Casa Guidi
Windows," which is not only a noble poem, but
the only book I have seen which, favouring the
Liberal cause in Italy, gives a just account of the
incapacities of the modern Italian.
Note M, page 92. Salisbury spire is only a tower
with a polygonal gabled roof of stone, and so also
the celebrated spires of Caen and Coutances.
Note N, page 101. The reader is not to suppose
that Greek architecture had always, or often, flat
ceilings, because I call its lintel the roof proper. He
must remember I always use these terms of the
first simple arrangements of materials that bridge
a space; bringing in the real roof afterwards, if I
can. In the case of Greek temples it would be vain
to refer their structure to the real roof, for many
were hypæthral, and without a roof at all. I am
unfortunately more ignorant of Egyptian roofing
than even of Arabian, so that I cannot bring this
school into the diagram: but the gable appears to
have been magnificently used for a bearing roof.
Vide Mr. Fergusson's section of the Pyramid of
Geezeh, "Principles of Beauty in Art," Plate I.,
and his expressions of admiration of Egyptian
roof masonry, page 201.
Note O, page 111. Late, and chiefly confined to

Appendix Northern countries, so that the two schools may
be opposed either as Early and Late Gothic, or
(in the fourteenth century) as Southern & Nor-
thern Gothic.

Note P, page 117. In many of the best French
Gothic Churches, the groups of figures have been
all broken away at the Revolution, without much
harm to the picturesqueness, though with griev-
ous loss to the historical value of the architecture:
whereas, if from the niche at Verona we were to
remove its floral ornaments, and the statue be-
neath it, nothing would remain but a rude square
trefoiled shell, utterly valueless, or even ugly.

HERE ends the Nature of Gothic, by John Rus-
kin, printed by William Morris at the Kelmscott
Press, Hammersmith, and published by George
Allen, 8, Bell Yard, Temple Bar, London, and
Sunnyside, Orpington.

'NO BOOK OF MINE has had so much influence on contempo-rary art as the *Stones of Venice*; but this influence has been pos-sessed only by the third part of it, the remaining two thirds having been resolutely ignored by the British public.' Ruskin wrote this in 1873, twenty years after the book came out. By then, the Gothic Revival had become the Gothic Pastiche, as what Ruskin called 'the Frankenstein monsters' of Victorian Gothic attempted to disguise factory chimneys as campanili, and turn Victorian pubs into Venetian palazzi.

But as Ruskin more than hinted, *The Stones of Venice* was not just about architecture. The Gothic was a metaphor for the right relationship between man and nature, and for the right conduct of society. That his use of architecture as a moral metaphor should be reprinted not once but twice in his lifetime, shows that 'the re-maining two thirds' of his message was not entirely ignored. It did indeed, as Morris wrote, 'point out a new road on which the world should travel'.

'The Nature of Gothic' is the keystone to the architecture of *The Stones of Venice*. The chapter is set at the centre of the sec-ond of its three volumes, and is supported by studies of two build-ings: the Byzantine St Mark's, and the Gothic Ducal Palace. Unlike these chapters, however, it is ahistorical, addressing neither a par-ticular building nor a particular period. It is able to stand alone because it is not about the historical details, but the moral essence of 'Gothicness'. And just as the chapter marks a turning point in Ruskin's narrative of the rise, decline and fall of Venice, it also marks a point of transition in the trajectory of his thought: from art critic to cultural historian; from cultural critic to social critic.

The key to what Ruskin meant by the Nature of Gothic is that the six characteristics he identifies are simultaneously formal, æsthetic categories, and what he calls 'moral elements'. Each æs-thetic category: Savageness, Changefulness, Naturalism, Grotesque-ness, Rigidity and Redundance; has its correspondent human

characteristic: Rudeness (meaning rough virility rather than bad manners), Love of Change, Love of Nature, Disturbed Imagination, Obstinacy and Generosity. Not all six are given equal weight or development. Crucially, 'Grotesqueness', by which he meant not absurdity, but the transformation of fact into symbol by the 'Disturbed Imagination', was set aside for discussion in the last volume of *The Stones*, where it plays a crucial role in the evolution of Ruskin's theory of symbolism.

The title of the chapter is carefully crafted, for 'Nature' means more than essence, it is also the ruling spirit of the values that he identifies. The single word that encapsulates that spirit is the one that Ruskin used to convey all the positive values he argued for in his later economic writings, quite simply: 'life'. The organicism, the energy, the variety, the abundance of Gothic architecture expressed this vital quality. Yet, after the hungry 1840s, and the year of revolutions in 1848 that had put Venice under siege, Ruskin saw that man was alienated from Nature. It was a double alienation: man had crowded into cities, where he tried to compensate for his separation from the natural world through the evolution of Gothic architecture. And now man was alienated also from the Gothic. The forces of Classicism and Industrialism had combined to turn men into slaves.

Ruskin was building in part on the Romantic tradition that he had inherited from Wordsworth, but there are two shaping ideas that gave his argument a distinct inflection: his Protestantism, and his Toryism. In 1853 he was still committed to the Evangelicalism instilled by his parents. His competitor as prophet of the Gothic Revival was the English Catholic convert Augustus Welby Pugin, who specifically linked architectural reform to Roman Catholic revival. Just as committed to spiritual revival, Ruskin owed Pugin a great deal more than he would ever be prepared to acknowledge. Pugin's death in 1852 left him free to redouble his efforts to cleanse the Gothic Revival of papist taint; the attack on

'foolish foliation' in 'The Nature of Gothic' is a covert criticism of Pugin's work on Sir Charles Barry's new Houses of Parliament.

The religious politics of the Gothic Revival help to explain why Ruskin could so determinedly describe an architecture that long predated Protestantism, as Protestant. Over against the rule of the Roman Catholic hierarchy, which in the Counter-Reformation had reintroduced 'Pagan' – that is to say Classical – architectural forms, Ruskin stressed the individualism of the Gothic, its 'Protestant spirit of self-dependence and enquiry'. In the 1850s, to be an Evangelical Protestant was also to be an Ultra-Tory.

In the light of his influence on the road taken by the English Left – notably William Morris – Ruskin's Toryism may appear paradoxical. Yet it was entirely consistent with his organicism. Ruskin's politics looked back to an idealised, agriculturally-based society rather than forward to a grasping economic individualism that exploited the division of labour. A romantic anti-capitalist, he imagined pre-lapsarian Venetian society as a benign hierarchy of statesmen, soldiers, artists and craftsmen bound together by common rights and duties, where each man knew and kept his place, but enjoyed the freedom and security that it gave him.

Industrialism had destroyed that freedom. Ruskin's analysis of the Nature of Labour is conservative and revolutionary at the same time. He knew nothing of Marx, but both were addressing the same social and economic conditions at the same period, and both concluded that man's alienation was the consequence of having the value of his labour stolen from him. For Marx, the value was economic; for Ruskin, it was æsthetic. Any man has some capacity, however small, to create, and in that capacity lies his humanity. But the division of labour, Ruskin argued – taking Adam Smith head-on by using the example of pin-making that Smith used in The Wealth of Nations – meant that 'it is not, truly, the labour that is divided; but the men'. Atomised, men become mere parts of an industrial machine. Thus it should be no surprise that the 'great

cry that rises from all our manufacturing cities' was that 'we manufacture everything there except men'.

Again, this is an æsthetic argument: the rules of Classical, 'Pagan' architecture demanded a regularity, a symmetry, a consistency of repetition that left no room for individual, 'Protestant', self-expression. It was Roman slavery all over again. Worse, the industrialisation of labour made it possible to demand perfect finish, and to achieve an untruth to materials that created the modern domestic interior, whose 'perfectnesses are signs of a slavery in our England a thousand times more bitter and more degrading than that of the scourged African, or the helot Greek'.

The answer to this æsthetic and industrial oppression was to rediscover the liberating qualities of the Gothic: its fecundity, its vitality, its flexibility, its expressiveness. Above all, its imperfection. 'The Nature of Gothic' articulates Ruskin's Doctrine of Imperfection. This does not mean that the artist should seek imperfection, but that he must accept that 'no good work whatever can be perfect'. The artist must do the utmost to extend his creative capacities as far as they will go, but objectively, he can go no further. Ruskin names an eclectic group of artists who outreach the rest, and whose perfections, it should be noted, are all very different. The noble artisan must similarly be encouraged to put all his expressive qualities into his work, however limited his capabilities and savage the results. 'Perfect' craftsmanship is dead craftsmanship, whereas the infinite plenitude of the Gothic has space within it to accommodate everything from the slightest skills to the greatest powers.

Two cultural traditions support this argument. The first is Romantic: 'imperfection is in some sort essential to all that we know of life'. Bearing in mind the particular value that Ruskin placed on 'life', art and architecture can only be a response to the greater natural world, which is itself imperfect. But behind that stands a much older and stronger tradition, the theological tradition

of the Fall. Art can but be imperfect, because man is imperfect. He is a fallen creature because of Adam and Eve's original sin, just as the earth bears the scars of the punishment of the Flood. Because of the Fall, Paradise is lost. Understanding this, the pursuit of perfection and the failure to acknowledge our fallen nature become arrogance, folly, even blasphemy.

The corollary, however, is that if man is a fallen creature, he may yet be saved, and if Paradise is lost, it may yet be regained. Thus the doctrine of imperfection, which seeks to acknowledge this fallen state, also brings with it the possibility of redemption. We must use what few creative capacities that we have to realise our own nature, and so find our place in the great chain of being that will lead us, ultimately, to God. The first step is to overcome our alienation from God's own creation, Nature, and find its æsthetic correspondence, in the Gothic.

* * *

This analysis of the æsthetic and moral alienation of Victorian Britain had a broad appeal for Ruskin's contemporaries. The first to use 'The Nature of Gothic' as a form of independent manifesto were, not surprisingly, the Christian Socialists. In 1854, just a year after the completion of The Stones of Venice, they had gathered round the Reverend Frederick Denison Maurice to set up the London Working Men's College. Among the group was Ruskin's friend and admirer, F. J. Furnivall, who asked him if he would allow the chapter to be printed separately, and sold as a fund raiser at the College's launch that October. In spite of his Toryism, and his less than perfect sympathy with Maurice's views, Ruskin not only agreed, but offered to take on responsibility for the drawing classes. This generosity was rewarded, for it brought him into regular working contact with the Pre-Raphaelite generation of British artists, including Burne-Jones and William Morris, and encouraged him to pursue his critique of contemporary society by writing on

political economy. Ultimately, the experience led to the formation of his utopian vehicle for social reform, the Guild of St George.

The pamphlet for the London Working Men's College was published with the added, and larger, sub-title and herein of the TRUE FUNCTION OF THE WORKMAN IN ART. It sold for fourpence. Even in the sixpenny second printing, in an orange wrapper with an illustration of the Ducal Palace, it is a very humble production in comparison to the high art presentation of William Morris's, a limited edition of 500 copies printed on hand-made paper with a fine vellum binding. It is based on the 1886 edition of *The Stones of Venice*, but by 1892 Ruskin was no longer capable of managing his own affairs. Once agreement to publish the chapter had been reached with Ruskin's de facto keeper, his cousin Joan Severn, the details would have been handled by George Allen, a former pupil at the London Working Men's College who rose to become Ruskin's personal publisher, and who acted as distributor for this fourth production of the Kelmscott Press.

In his introduction Morris stresses the 'ethical and political considerations' of Ruskin's message. His summary that 'art is the expression of man's pleasure in labour' grasps Ruskin's essential point. But the actual appearance of the book might suggest that the new road on which the world should travel headed towards a greenery-yallery fantasy of romantic medievalism, preferably lived out in the æsthetic suburb of Bedford Park. That was not Morris's intention at all. He had learned from Ruskin that books must be as beautiful as possible, because we must always reach for the highest expression of which we are capable. Æsthetic endeavour was a moral obligation, and beauty carried a political weight. In its craftsmanship, the vitality of its design, the fecundity of its imagery, and even its tiny imperfections, Morris's edition embodies the nature of Ruskin's Gothic.

WILLIAM MORRIS WAS A FORMIDABLE literary Time Traveller, capable of giving both the hero of H. G. Wells's *The Time Machine* and even Dr Who himself a run for their money; and from one end of time to another what he finds (or brings with him) is the Ruskinian Gothic. In *A Dream of John Ball* the narrator wakes up outside a Kent village just as the Peasants' Revolt of 1381 is breaking out, and in Morris's great masterpiece, his utopia *News from Nowhere*, the narrator William Guest arrives in a transfigured socialist London of the mid-twenty-second century. Not quite H. G. Wells's 802,701 AD, perhaps; but none the less Morris's nearly eight hundred year span of æsthetic exploration is impressive enough, particularly in a century whose literary production was dominated by the realist novel, with its meticulous exploration of the everyday, the humdrum, the contemporary.

Morris and the Nature of Gothic

Tony Pinkney

And what do you find as you climb off your Wellsian time machine or, in Morris's low-tech version of this, wake up from (or into) your time-travelling dream? Well, in John Ball nothing other than the very cultural sources of Ruskin's Gothic vision in the 1300s, as pristine and gleaming as if you were Adam waking up and seeing everything in Eden for the very first glorious time; or – if your literary Tardis takes you by chance in the other direction – a far-flung socialist future which has ambitiously reshaped so many details of its working routines and cultural practices to re-embody that original fount of pure medievalism all over again. What you find above all, as the underlying social principle of all the quaint or bewildering surface details of which you as time-travelling narrator have slowly to make sense, is the ultimate Ruskinian principle (at least as Morris understood Ruskin) of pleasure and creativity in labour. For this, as William Guest confesses to Old Hammond in *News from Nowhere*, is a 'change from the conditions of the older world ... far greater and more important than all the other changes you have told me about' (ch. XV).

Ruskin's 'On the Nature of Gothic' was, then, in Morris's

grandly ebullient phrase, 'one of the very few necessary and inevitable utterances of the century'. High praise indeed, though Morris's phrase 'one of ...' also makes me want to ask what the other such utterances would have been for him: Karl Marx's *Das Kapital* certainly, some key novels by Walter Scott and Charles Dickens probably, perhaps even Edward Bellamy's utopia *Looking Backward*, though this would have been 'necessary and inevitable' in exactly the wrong kind of way for Morris – centralist, reformist, urbanist, high-tech – thereby prompting him to a fierce rejoinder in the form of his own decentralist ecotopia *News from Nowhere*. But Ruskin's great chapter, though it would in Morris's view be life-changing in whatever printed form you might come across it, deserved better than the standard printing practices of the nineteenth century; it ought, he must surely have felt, to be Gothic in terms of form as well as content, to physically embody the key Ruskinian values of savageness, changefulness, naturalism, grotesqueness, rigidity and redundancy as well as to propound them intellectually in its own semantic content. Thus when Morris founded the Kelmscott Press in his later years, Ruskin's great defence of the virtues of medieval architecture and craftsmanship must have seemed an inevitable choice to issue from a private press which was itself trying to reinvent such values, all the way from typeface design to the position of the text on the page to the handmade paper or the vellum it was printed on. To put Ruskin's manifesto out in this manner would give it tactile as well as intellectual impact, would integrate Gothic design and Gothic content, thereby contributing to that 'eventfulness of form' which Morris expounded in his lectures on art. The physical materiality of a Kelmscott volume quite as much as its semantic substance is an impassioned political statement in Morris's eyes.

No doubt Morris was constitutionally, even physiologically, primed for the Ruskinian Gothic message which would hit him so hard and so formatively when he first came across it as an

undergraduate at Oxford in the 1850s; for as Fiona MacCarthy's great 1994 biography has so amply demonstrated, the Ruskinian litany of rudeness, love of change, love of Nature, disturbed imagination, obstinacy and generosity is certainly a good summary of Morris's colourful and sometimes explosive character, and even perhaps of his very somatic existence itself, jerky, abrupt and incessantly hyperactive as that most certainly was. But 'On the Nature of Gothic' became for him also an intellectual passion, first as applied specifically to the world of the arts and crafts, but in later years reaching more fully into the whole question of social reorganisation as such. For one could show, I suspect, that in his utopia *News from Nowhere* it is not just the quality of the everyday artefacts that is savage, changeful, naturalistic, grotesque, rigid and redundant as Ruskin required, but the very quality of utopian social life itself, particularly as that is represented by the extraordinary figure of the young woman Ellen in the last third of the text.

We have had various generic labels over the years for the kind of social thinking that Ruskin and Morris represent. For a long time they were grouped together with figures like Thomas Carlyle, Matthew Arnold, John Stuart Mill and even H. G. Wells as 'Victorian Sages' or 'Victorian Prophets', terms which certainly capture something of the lofty rhetorical stance from which several of them launch their social critiques, but which do not say anything very helpful about the actual content of such critique. In 1958 a new term came along, with Raymond Williams's superb book, *Culture and Society: 1780-1950*, which studied British social thought from Edmund Burke and William Cobbett to T. S. Eliot, F. R. Leavis and George Orwell. The 'culture and society tradition' then became a catch-all term for a mode of wide-ranging social criticism emerging from the Romantic literary tradition. More recently and more specifically, we have come to speak of 'Romantic anti-capitalism', a term which fully encompasses Carlyle, Ruskin, Morris, Lawrence, Eliot and Leavis, though it would omit liberals like Arnold

and Mill. Romantic anti-capitalism, as its name suggests, is a powerful denunciation of what it sees as the philistine, grimly utilitarian, dehumanised oppressions of capitalist society, but it launches this attack not in the name of the organised working class and a possible socialist future, but of a vanished past: some 'paradise lost' or distant happy Hobbitland in which life was vivid, vigorous, charismatic and creative, before everything was so drably subjected to Carlyle's 'cash-nexus' or Marx's 'dull compulsion of the economic'. That precious lost past can be situated all over the place, historically and geographically speaking: in the Gothic Middle Ages for Carlyle, Ruskin and Morris, but also in Renaissance Italy or the samurai culture of feudal Japan or legendary Ireland (W. B. Yeats) or in primitive tribal cultures that just survive at the very edges of modernity (D. H. Lawrence and others).

The invocation of Yeats here can remind us of just what a politically labile thing Romantic anti-capitalism is: it is always at the political extremes, never in the liberal centre. Morris himself commits all his prodigious energies to revolutionary socialism when he joins the Democratic Federation in January 1883, crossing what he termed a 'river of fire' from Victorian bourgeois comfort to the militant working-class cause; and when the Ruskin-Morris tradition comes through into the early twentieth century in Germany in the early Bauhaus under Walter Gropius it is again passionately on the Left, as Lyonel Feininger's invigorating avantgarde woodcut of the 'Cathedral of Socialism' testifies. But for other Romantic anti-capitalists, socialism was the problem rather than the solution; it appeared to them to be just one further exacerbation of the materialist trends of capitalism itself. At which point, this social tradition can move very far to the political Right indeed, as it does with Yeats himself (despite his youthful closeness to Morris), who in the 1930s was writing marching songs for the Irish 'Blueshirts' or Fascists. And if German Expressionism was on the left in the early Bauhaus, it too could move dangerously to the right as with

the poet Gottfried Benn. Nazism itself might be seen in some of its motifs to be Romantic anti-capitalist, as in its emphasis on *Blut und Boden* (blood and soil) rather than rational thought. Today, blessedly, it is the Green movement which is for us the contemporary political embodiment of the Romantic anti-capitalist tradition, and which itself often harks back to Ruskin and Morris as its ideological progenitors.

Gothic is in fact everywhere in our own culture; but it is alas, for the most part, not the Gothic of Ruskin and Morris. To understand why this should be so, we need to go back in literary and cultural history; for Gothic has never been a single tradition but is, rather, bifurcated from the very start. It is not only the name of an architectural mode which, when positively revalued in the Romantic period, becomes a politics of social hope and creative labour in Ruskin and Morris. It is also the name of a female or even feminist mode of writing, all the way from the novels of Ann Radcliffe through the Brontë sisters to (among others) the eerie fairy stories of Angela Carter. This is a dark literature of incarceration, sexual menace, oppressively labyrinthine castles or country mansions, ghosts and ghouls, and of raging 'madwomen in the attic' like Charlotte Brontë's Bertha Mason; and it is this dark Gothic, of which there is a male tradition too, from Edgar Allan Poe through Bram Stoker to Stephen King, which is then generalised out so powerfully in the mass media of the late twentieth and early twenty-first centuries. Switch on the television any evening of the week and you can have your fill of film and drama involving vampires, werewolves, zombies, monsters, the undead in every conceivable shape and form. Such motifs are pervasive in literary and cultural studies too; so many of my younger academic colleagues seem to be working on novels or films about serial killers, predatory aliens, virulent ghosts, hideous genetic mutations, or in general the terrifying boundary between life and non-life. And this tradition then percolates into youth subculture

itself, where 'Goths' names both a lifestyle and a mode of popular music.

I used to work on that kind of disturbing material myself once upon a time, feeling that it is at its dangerous and dystopian cultural edges – for which 'Gothic' will do as well as any other term as a generic name – that a culture best explores its paranoid fears and limits. But now, in mellow middle age, I feel that such analytic concerns can themselves become part of the very cultural pathology they are exploring; more of a symptom of the problem than any sort of cure for it. At which point it is, surely, more than ever important to remember – to reactivate – the Ruskinian and Morrisian Gothic, to speak, as it does, for social hope rather than despair, for potential delight rather than pervasive darkness. Ruskin and Morris no doubt both felt that they were describing the Middle Ages as they genuinely, objectively were; and such a claim would then make them potentially vulnerable to later archæological and philological research. Suppose, after all, that it could be shown that medieval labour on those great cathedrals was not as creative and cooperative as had been supposed? But what Ruskin and Morris read as historical truth *tout court*, we would do better to understand as an inspirational myth, a utopian vision of what our social life could once again be like, on the other side of capitalism, whether or not it ever had in actual fact been like that in the Gothic past or not.

If we indeed live in the epoch of Francis Fukuyama's 'end of history' or of Peter Sloterdijk's postmodern 'cynical reason', an age in which the socialist challenge to capital has been not just defeated but virtually forgotten, then we need more than ever the utopian vision which Ruskin and Morris gave to us, a vision of the systemic, total transformation of a bad society, not just reformist tinkering around its edges. Ruskin and Morris give us the intellectual resources to keep full-blooded utopian thinking alive in a way that few other nineteenth-century writers do; and for that we

remain enduringly in their debt (at least until we finally arrive at that good future, and then we won't politically need them any more!). Ruskin gives us the rousing manifesto of these utopian motifs in 'On the Nature of Gothic'; Morris beautifully fleshes out what Gothic in this sense might mean in detail in *News from Nowhere*; and he gives us in his Kelmscott Press edition of the Ruskin chapter a beautifully crafted artefact from that far-distant mid-twenty-second century future, lovingly brought back just as H. G. Wells's Time Traveller brings back Weena's flower from 802,701 AD. For this is the physical form in which the utopians of the future will read their Ruskin; and as we today read this timely facsimile version of the Kelmscott text surely we can hear their voices quietly but persistently all around us, ghosts from a gleaming future not from a terrifying past, asking us to commit ourselves to building the good world which Ruskin's marvellous prose, that 'necessary and inevitable utterance' of the nineteenth century, so forcefully enjoins upon us. As W. H. Auden put it in his own dialogue with the future in 'Spain 1937': 'What's your proposal? To build the Just City? I will'.

Patterns of Meaning: Ruskin, Morris and the Nature of Gothic

Robert Brownell

ACCORDING TO MORRIS HIMSELF, the two most important and desirable productions of Art were beautiful houses and beautiful books, in that order. The enjoyment of good houses and good books 'in self-respect and decent comfort', seemed to him to be 'the pleasurable end towards which all societies of human beings ought now to struggle'. But do not think for a minute that putting good houses and good books together in this way was merely the head of a wish list of bourgeois comforts. The connections between architecture and books were far more important than that. Morris's first biographer, noting that Morris had abandoned an architectural apprenticeship in order to concentrate on art and design, pointed out that for Morris

> then and always, the word architecture bore an immense, and one might almost say a transcendental, meaning. Connected at a thousand points with all the other specific arts which ministered to it out of a thousand sources, it was itself the tangible expression of all the order, the comeliness, the sweetness, nay, even the mystery and the law, which sustain man's world and make human life what it is. To him the House Beautiful represented the visible form of life itself.[1]

In the nineteenth century the idea that buildings could be read like books was commonplace, but there can be little doubt that it was in John Ruskin's *The Seven Lamps of Architecture* and *The Stones of Venice* that Morris discovered the truly transcendental meanings of architecture and the architectural qualities of books. In both these works, Ruskin consistently described architecture as a language which needed to be learned and understood and buildings as books to be read. Thus the capitals of the Ducal Palace at Venice were to be 'read, like the pages of a book', and St. Mark's church was an 'illuminated missal' and a 'Book-Temple': 'never had city a more glorious Bible'. The city of Venice itself 'lay open on

the waves, miraculous, like St. Cuthbert's book – a golden legend on countless leaves.'

The formal structure or composition of a building had its story to tell, but communicating the full wealth of meaning of which architecture was capable needed the skill of the artist. Painters and sculptors released the full expressive resources of buildings by their work on them, which could range from representational sculpture and narrative fresco to the simplest decoration and pattern. In *The Seven Lamps* Ruskin had argued that it was its capacity for such expression that set Gothic architecture apart from the rest:

> It is one of the advantages of Gothic architecture [...] that it admits of a richness of record altogether unlimited. Its minute and multitudinous sculptural decorations afford means of expressing, either symbolically or literally, all that need be known of national feeling or achievement.[2]

For Ruskin the finest constructions functioned as the finest meaning carriers but 'better the rudest work that tells a story or records a fact than the richest without meaning'. The meanings of both architecture and books were however not always in plain view. In *The Seven Lamps* the significance of the Lamp of Beauty chapter was not immediately apparent until its central position in the text was fully appreciated by the curious intellect. The planetary nature of his Lamps was similarly presented in an occult manner by specific references to the ancient myths and to their astrological nature. These were the kind of 'stories', implicit in both the architecture and literature of the Middle Ages, which Ruskin embedded in his architectural works. 'The Nature of Gothic' chapter of *The Stones of Venice* occupies a similar significant centrality in the second of the three volumes. The reader is alerted to Ruskin's design by the title of the volume which contains a characteristic Ruskinian play on words, as he admitted to his father:

The second volume is to be called the Sea Stories, for what on land we call a ground floor, I always call in speaking of Venetian building the Sea Story, and this will give you the same kind of double meaning to the title of the second volume that there is in the first.[3]

Ruskin's readers were intended to 'see stories' in both the architecture and his book. The famous categories of the Nature of Gothic – Savageness, Changefulness, Naturalism, Grotesqueness, Rigidity and Redundance – were of course direct descendants of six of his planetary 'Seven Lamps of Architecture': Mars, Moon, Mercury, Jupiter, Saturn and Venus.[4] Like the Ducal Palace capitals Ruskin's allegorical lamps presented a perfect fusion of Nature, History and Poetry, but not all his architectural ornament was of such over-arching significance. In *The Stones of Venice I* he had suggested a more modest approach. Those forced to live in cities, he wrote, lose 'fellowship with nature'. 'We cannot all have our gardens now, nor our pleasant fields to meditate in at eventide. Then the function of our architecture is, as far as may be, to replace these; to tell about Nature'; it should therefore be 'full of delicate imagery of the flowers we can no longer gather, and of the living creatures now far away from us in their own solitude.'[5] Nature was an ideal subject for decoration because it was constant, familiar and accessible to the most people.

Morris too stressed that ornament and decoration must always carry meanings: 'You may be sure that any decoration is futile and has fallen into at least the first stage of degradation, when it does not remind you of something beyond itself, of something of which it is a visible symbol.' 'You will probably admit,' he wrote:

> when you come to think of it, that every work of man
> which has beauty in it, must have some meaning in it also;
> that the presence of beauty in a piece of handicraft implies
> that the mind of the man who made it was more or less

excited at the time, was lifted somewhat above the commonplace; that he had something to communicate to his fellows which they did not know or feel before, and which they would never have known or felt if he had not been there to force them to it.[6]

Quite what this meaning might be is only ever hinted at, mainly because the possibilities are limitless. Beyond the merely sensual pleasure of representations of nature is a whole landscape of associations wherein lie the hidden grottos of symbolism. We should perhaps not expect to find in Morris's fabric patterns the complex typological symbolisms of Pre-Raphaelite easel paintings, nor the cosmological allegories of Ruskin's books but like Ruskin, Morris too demanded that his architectural interiors should bear 'unmistakeable suggestions of gardens and fields'. However, the range of associations which a piece of handicraft might evoke or suggest could be far beyond that part of nature which they appear to represent. Your teachers in such design, according to Morris, should be both Nature and History; and he pointed out how a piece of historical design could speak volumes about both. The ancient craftspeople who made beautiful Eastern rugs

> in their own way meant to tell us how the flowers grew in the gardens of Damascus, or how the hunt was up on the plains of Kirman, or how the tulips shone among the grass in the mid-Persian valley, and how their souls delighted in it all, and what joy they had in life; nor did they fail to make their meaning clear to some of us.[7]

In this way 'you must not only mean something in your patterns but must also be able to make others understand that meaning.'

The mysterious properties of pattern and design are intuitively felt but difficult to trace. Morris consistently advised designers and makers to 'conventionalise' their designs by retaining

the sense of natural form and growth but without being tempted to reproduce nature slavishly with botanical and scientific accuracy. To introduce scientific fact in that way would only serve as another reminder of the hard world of work. He believed that the pleasure we take in a beautiful pattern comes from the interplay between the representation of nature and our being able to detect an ordering intelligence in the way it is composed. There is however much more than mere botanical arrangement in a simple pattern or representation. The patterns of meaning are what really count. The beauty of both Morris's and Ruskin's intricate designs is that the eye is occasionally led beneath the surface of what they have created and that which is hidden in the work of art is often revealed in the mind of the perceiver.

The professed theme of *The Stones of Venice* is how the foundation, rise, peak, decadence and fall of the Venetian state can be clearly read in its art and architecture. The lesson thus derived from history was however intended as a warning for another state: Victorian England. In *The Seven Lamps of Architecture* Ruskin had shone the full light of his intellect upon the things his countrymen made and found them wanting. He not only criticised the ugly machine-made products that had flooded the market, but also attacked the entire socio-political system by which they were produced. The dominant ideology of the nineteenth century was defined by the Old Testament political economy of Adam Smith, which was based on the general view of work as part of the Biblical Adamite curse: 'In the sweat of thy face shalt thou eat bread, till thou return to the ground'.[8] Having absorbed the Calvinist conviction that all mankind was irredeemably tainted with original sin, Smith therefore had assumed that mankind had a natural propensity to idleness and selfishness and that work was divinely ordained to be 'toil and trouble'. Wealth therefore was having sufficient money or goods to get other people to do the unpleasant work for you.[9] The result was a conflict model of two opposed classes,

one of which sought to exchange their labour for the means of subsistence, the other to purchase and direct that labour at the lowest rate possible in order to avoid the 'toil and trouble' and maintain themselves in a state of leisure and ease. Ruskin did not subscribe to the idea that a life of leisure was desirable for anyone and vehemently opposed the idea that work should invariably be unpleasant 'toil and trouble'. Indeed he came to believe that 'life without industry is guilt and industry without art is brutality.' Life, he thought, should be joy in doing – even if that involves perseverance and difficulty. Human activity – work itself – was not just a punishment for original sin or a test of self-sacrifice, but could be a joyful exercise of human capabilities stretched to their fullest extent. If the workman's actions were made dull, repetitive and mechanical, then all the life disappeared from both the workman and the work. According to Ruskin art was the expression of man's pleasure in his labour. The proper question to ask with respect to all art applied to buildings and their appurtenances was therefore this: Was it done with enjoyment and was the craftsman happy while he was about it? What made the difference was the freedom of the workman to exercise his creativity on the things he made. This was the essence of Ruskin's attack on Adam Smith in his 'Nature of Gothic' chapter.

This joy in doing work had far-reaching consequences. Ruskin argued that, if rightly interpreted, the social and political condition of the workman could be read not only in the buildings he raised but even in the simplest pattern or design he created. Like the sense of power that came from overcoming difficulty, the artistic principle of 'joy in doing' became an actual recognisable quality in the thing created, the visible expression of a state of mind and could be appreciated by the beholder as the quality Ruskin called 'life'. This was not just a measure of artistic freedom; it was also a sign of the political condition of the creator. Only if the craftsman was allowed the freedom to choose, to design and

therefore to err or fail, could he put his whole being into his work and develop his skills. If the craftsman was too rigidly supervised and directed, if he was forced to carry out repetitive and menial tasks, then his work became a form of slavery and he became more a tool than a man – a state of affairs demonstrated by the lifeless quality of the end result.

According to Morris, before the present capitalist system was imposed on society:

> everything that was made by man was adorned by man, just as everything made by Nature is adorned by her. The craftsman as he fashioned the thing he had under his hand, ornamented it so naturally and so entirely without conscious effort, that it is often difficult to distinguish where the mere utilitarian part of his work ended and the ornamental began.[10]

The craftsman's original purpose in this ornamentation was to make his work more varied and interesting, but the great gift of art and beauty to the world which resulted from such a mundane purpose was enhanced by being stamped with the impress of the obvious pleasure the craftsman took in his work. With the imposition of the capitalist system all this artistic creativity ended. For Adam Smith and his followers the sole aim of the capitalist entrepreneur was to create monetary profit. Art, beauty and pleasure simply did not enter into the equation. In order to maximise such profit Smith suggested that work be divided into a multiplicity of simple repetitive menial operations. The result was to de-skill the craftsman who could then be paid less in wages. The craftsman became merely a hired hand, directed in all his actions by the instructions of his master. The division of labour meant that the designer and the maker often became two separate people. If ornament was ordered it must be specially paid for and the craftsman paid for his extra time. What was once done freely with pleasure

became just another addition to his wage-burden and yet another folly of useless toil.

Because Morris himself was both a craftsman and an entre- preneur he would have been well aware of the dilemma facing the artist-maker under a capitalist system. Even if the craftsman man- aged to free himself from a capitalist overseer, what if his client was unwilling to pay more for the extra time the maker spent mak- ing his product truly beautiful? How then would his labour be properly rewarded? In *News from Nowhere* Morris suggested that the primary reward of labour was life, but the reward for especially good work was 'the reward of creation. The wages which God gets, as people might have said time agone.' To ask for extra pay- ment for what should be done as a matter of course would be like 'a bill sent in for the begetting of children'. Every true craftsman working on a fixed price commission has at some time or other put in those extra hours, fully aware that his only reward will be 'God's wages'.

The reprinting of the 'Nature of Gothic' chapter of *The Stones of Venice* perfectly illustrates the craftsman's dilemma. The chapter had already been separately reprinted by Ruskin's publisher Smith Elder & Co in 1854 as a cheap utilitarian paperback tract. The price was deliberately held down to fourpence in order to be af- fordable to working men. Morris's Kelmscott edition was aimed at an entirely different market. It was printed on English hand- made paper using Morris's deeply researched black ink and with the 'golden type' font which Morris had designed himself. The text was bound in in gilt-lettered antique limp vellum boards. Five hun- dred copies were produced which sold at thirty shillings each. Within a very few years these were changing hands for more than double that amount. But once again we should beware of dismiss- ing the whole 'Nature of Gothic' enterprise as a mere pandering to bourgeois luxury. Morris's book challenged the dominant ide- ology with every aspect of its form and content. The hand-laid

linen paper, the consummate pattern designs of its ornamental borders, the ample and exquisite proportions of its page margins, the hand-crafted typeface, the two sizes of ornamental capitals, all served to demonstrate that uncalculating bestowal of the wealth of labour which Ruskin called 'redundance'. The text itself contained a sustained criticism of every aspect of the classical economics of the Gradgrind generation, but the book itself was much, much more than that. Hidden in the ornament, the compositional structure and the allegorical references were stories of a different world, a world where nature was a solace, 'art' was as natural as a smile, and beauty was more precious than profit. The contrast between this and the world in which Ruskin and Morris lived was indeed stark, but much more so is the contrast with this hideous twenty-first century world of ours. Buildings are still our most truthful biographers and there are still stories to be read, albeit unpleasant ones, in the so called art and architecture we produce. In the arid desert of the modern built environment you will find little trace of nature or history, or art or beauty, or any sign of pleasure taken or given, but besides the Ozymandian sneer of the modern architect you will still discern the cold dead hand of eighteenth century political economy, and that is no fairy story.

1. J. M. Mackail, *The Life of William Morris*, 1899, vol. I, p. 89
2. J. Ruskin, *The Seven Lamps of Architecture*, 1849, VI.VII
3. John Ruskin to John James Ruskin, 16 October 1851
4. R. Brownell, *A Torch at Midnight*, 2017
5. J. Ruskin, *The Stones of Venice*, vol. I, chapter XXX, Section VI
6. W. Morris, *Some Hints on Pattern Designing*, 1881
7. W. Morris, *Making the Best of It*, 1879
8. Gen. 3.9
9. A. Smith, *Wealth of Nations*, 1776, I.V
10. W. Morris, *Useful Work versus Useless Toil*, 1884

MORE RUSKIN FROM PALLAS ATHENE

By Ruskin

THE STONES OF VENICE
A reader's edition, abridged by J. G. Links
Introduction by Colin Amery
978 1 873429 45 7 £14.99

UNTO THIS LAST
Arguably the most influential political tract ever written
Introduction by Andrew Hill, Associate Editor of
the Financial Times
978 1 84368 044 4 £9.99

THE STORM-CLOUD OF THE NINETEENTH CENTURY
The Storm Cloud of the Nineteenth Century is an eerily prescient
denunciation of capitalism's assault on the atmosphere. Ruskin's call
to action is even more urgently needed today.
Introduction by Peter Brimblecombe
978 1 84368 078 9 £9.99

'A NEW AND NOBLE SCHOOL': RUSKIN AND THE PRE-RAPHAELITES
All of Ruskin's writings on the Pre-Raphaelites,
edited by Stephen Wildman, introduced by Robert Hewison
978 1 84368 086 4 £19.99

THE KING OF THE GOLDEN RIVER
A fable, the first literary fairy tale in English
Illustrated by Richard Doyle
Introduction by Simon Cooke
978 1 84368 030 7 £7.99

MORE RUSKIN FROM PALLAS ATHENE

About Ruskin

THE WORLDS OF JOHN RUSKIN

Kevin Jackson

An introductory biography, with over 160 colour illustrations

Second revised edition

978 1 84368 148 9 £19.99

RUSKINLAND

Andrew Hill

✱ WINNER RUSKIN SOCIETY BOOK OF THE YEAR PRIZE ✱

An exploration of how Ruskin's life and writings created the world
of today and how they continue to influence us now

978 1 84368 175 5 £19.99

RAMBLING REMINISCENCES:
A RUSKINIAN'S RECOLLECTIONS

James S. Dearden

978 1 84368 105 2 £19.99

A JOHN RUSKIN COLLECTION

James S. Dearden

978 1 84368 152 6 £19.99

THE RUSKIN REVIVAL 1969-2019

Suzanne Fagence Cooper

978 1 84368 182 3 £19.99

RUSKIN AND HIS CONTEMPORARIES

Robert Hewison

HB 978 1 84368 176 2 £59.99

MORE RUSKIN FROM PALLAS ATHENE

MARRIAGE OF INCONVENIENCE
Robert Brownell

What really happened in the most scandalous love triangle
of the nineteenth century

HB 978 1 84368 076 5 £24.99

PB 978 1 84368 096 3 £17.99

A TORCH AT MIDNIGHT
Robert Brownell

�֍ WINNER RUSKIN SOCIETY BOOK OF THE YEAR PRIZE ✻

A new account of one of the greatest works on
the meaning of architecture ever writen

978 1 84368 142 7 £59.99

'AN ORIGINAL MONSTER':
THE CONTEMPORARY REVIEWS OF RUSKIN'S
SEVEN LAMPS OF ARCHITECTURE
edited by Robert Brownell

A unique picture of Victorian intellectual life

978 1 84368 079 6 £59.99

FLORA OF CHAMONIX
John Ruskin

edited by David S. Ingram and Stephen Wildman

A life-size facsimile of Ruskin's album of pressed flowers
collected in Chamonix in 1844, together with a full
botanical and historical commentary

Two hardback volumes in slipcase

978 1 84368 233 2 £175.00

First published as part of volume II of
The Stones of Venice, 1853; revised edition 1886.
The Kelmscott edition was first published in 1892,
designed and printed by William Morris using
the 1886 text; it was limited to 500 copies.
This facsimile of the Kelmscott edition
first published 2011 by
Pallas Athene (Publishers) Ltd
2 Birch Close, Hargrave Park,
London N19 5XD
Revised and expanded editions 2015, 2018, 2019,
2021, 2023, 2024

www.pallasathene.co.uk

 @Pallasathenebooks

 @Pallasathenebooks

 @Pallasathene0
issuu

© *Pallas Athene 2011, 2015, 2018, 2019,
2021, 2023, 2024*

ISBN 978 1 84368 101 4

Printed and bound in Great Britain by
TJ Books Limited, Padstow, Cornwall